IF YOU'RE BORED WITH ACRYLICS READ THIS BOOK

An Hachette UK Company

www.hachette.co.uk

First published in Great Britain in 2019 by Ilex, an imprint of

Octopus Publishing Group Ltd

Carmelite House

50 Victoria Embankment

London EC4Y 0DZ

www.octopusbooks.co.uk

www.octopusbooksusa.com

Distributed in the US by Hachette Book Group

1290 Avenue of the Americas, 4th & 5th Floors,

New York NY 10104

Distributed in Canada by Canadian Manda Group

664 Annette Street, Toronto, Ontario, Canada M6S 2C8

Design and layout copyright © Octopus Publishing Group Ltd 2019

Text and illustrations copyright © Denise Harrison 2019

Publisher: Alison Starling

Editorial Director: Zena Alkayat

Commissioning Editor: Zara Anvari

Development Editor: Ellie Wilson

Managing Editor: Rachel Silverlight

Art Director: Ben Gardiner

Designer: JC Lanaway

Production Controller: Sarah Kulasek-Boyd

ISBN 978-1-78157-647-2

A CIP catalogue record for this book is available from

the British Library.

Printed and bound in China

10 9 8 7 6 5 4 3 2 1

IF YOU'RE BORED WITH ACRYLICS READ THIS BOOK

DENISE HARRISON

ilex

CONTENTS

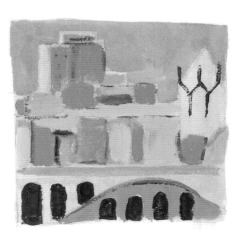

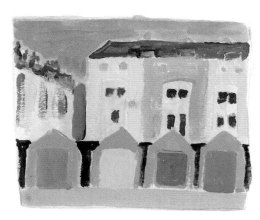

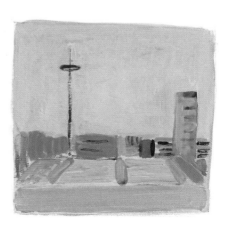

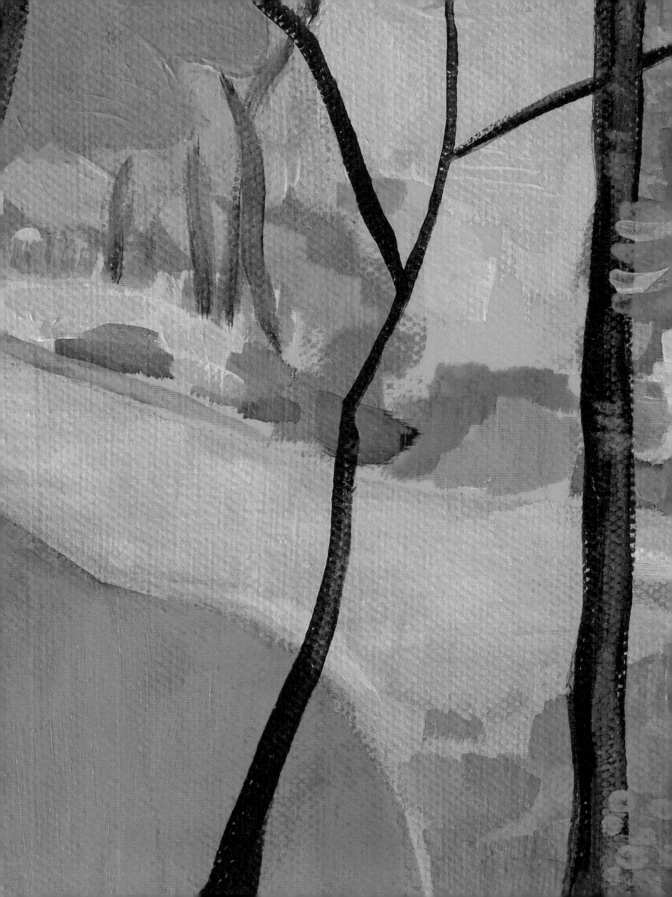

INTRODUCTION

Acrylic paint is a modern medium that was first used in the 1940s. It consists of a pigment that is suspended in a polymer emulsion, and it can be used on just about any surface. Acrylics are vivid and versatile. They've long been a favourite medium of mine, and I am so pleased to be able to share my enthusiasm for them with you.

The tutorials in this book have been devised to encourage you to explore many different aspects of painting with acrylics. They can be completed in any order. Don't get hung up on choosing a subject – which many people get stuck on – as you can simply copy the examples here if nothing springs to mind. The aim of the book is to teach you how to use acrylic paint and build your confidence in painting.

A lot of people are intimidated by the notion that you have to use different gels and mediums with acrylic paint – this is not the case, you can use just water. Gels and mediums enhance what acrylics can do, but they are not essential. Some of the tutorials do suggest using gels and mediums but most do not. By gaining a better understanding of acrylic paint and colour, you will be able to explore exciting ways of creating images.

Acrylics can also be mixed with sand, glitter, sawdust and other materials in order to change their consistency and appearance. They lend themselves well to working in mixed media, so I have included a chapter on this to encourage you to experiment with the medium, and push it to its limits.

> I hope you enjoy the tutorials, but mostly, I hope this book enhances your enjoyment of painting with acrylics.

One of the advantages of acrylic paint is that it dries quickly. This makes it an ideal medium for making small paint sketches or for larger paintings where you're working with a lot of layers. Unlike oil paints, you don't have to wait days for a layer to dry, so you can build up several layers of paint very quickly, with no mixing and muddying of the colours.

Some of the tutorials are fairly simple, while others are more detailed. Each tutorial focuses on introducing a specific technique that is relevant to artists of all abilities. You can always adapt the process, scale or subject to suit your preferences.

All the tutorials and techniques you'll find in this book are based on what I teach my students on the courses that I run in Brighton, UK. As a teacher, I am still always learning, and the more I paint, the more understanding I gain. Learning to paint well comes down to experimentation and practice. I hope you enjoy the tutorials, but mostly, I hope this book enhances your enjoyment of painting with acrylics.

ACRYLIC PAINT

As well as the different types of acrylic paint, there are also different grades within these; and then there are all the gels and mediums that can be added to the paint to alter its consistency, drying time and surface texture.

When faced with all these options, it can be difficult to know what to choose. Or perhaps you've never noticed the different options available, in which case this chapter introduces you to them, so that you can buy the paint and mediums that suit you best and will help you achieve the effects that you want.

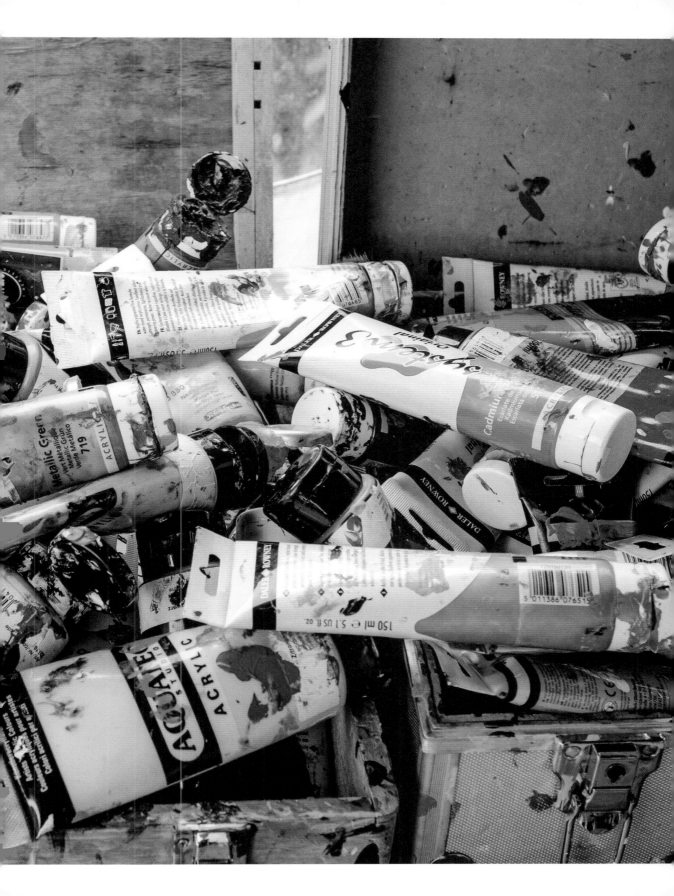

TYPES OF ACRYLIC PAINT

There are essentially three types of acrylic paint, each of which comes in two grades of quality: professional artist, and student.

Artist-quality paints tend to have a higher pigment concentration but are more expensive. Student-quality paints are perfect for learning. If you have spent a lot of money on paint, you might be more reluctant to experiment for fear of wasting it – yet experimentation is essential to learning and developing your painting skills. If you're on a budget, a good compromise is to buy the most vibrant colours in the artist grade, and neutral colours in the student grade.

 The three types that acrylic paint comes in relate to the viscosity of the paint, but all have the same amount of pigment. These are:

⟫→ HEAVY BODIED
The thickest of the acrylics. Its texture is like butter. It holds its shape when put on a palette, and is ideal for impasto painting without needing to add a medium; it easily forms peaks and is great for textures. This paint can be thinned out with water or an acrylic medium to increase its fluidity.

⟫→ SOFT BODIED
This paint has the consistency of custard. It can be moved around easily and will cover large areas well. It can be thinned down with water or a medium to make glazes, or made thicker and heavier by adding a medium such as an acrylic modelling paste.

⟫→ FLUID
This paint comes in bottles with a nozzle, making it easier to squeeze onto a palette or directly onto a painting. As its consistency is runny, it can run into other colours on your palette.

GELS & MEDIUMS

Gels and mediums make acrylic paints even more versatile. A heavy-bodied paint can become a soft-bodied paint by adding a medium, while a soft-bodied paint can be made to flow like a fluid paint, or, by adding a modelling paste, behave as if it were heavy-bodied.

Acrylic gels and mediums are generally made with a polymer, just as acrylic paint is. I use a palette knife to mix them into the paint to disperse them evenly. Most gels and mediums dry clear: they do not contain pigment, so they will dilute the pigment of your paint. For this reason you should buy good-quality paints if you are going to use gels and mediums.

I have listed a few gels and mediums here, but a complete list would be a lot longer, so do go and explore others that are available, and have fun experimenting with them.

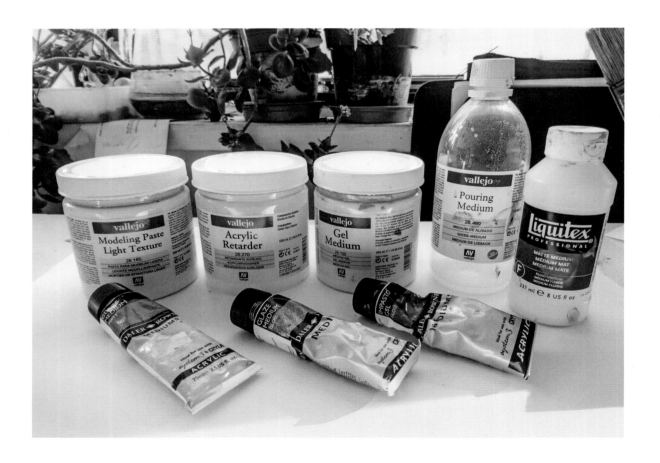

⫸ GLAZING

Glazing mediums can be added to acrylic paint to thin the paint and create a glaze. They come in matt and gloss options. Glazes allow you to paint a film of pigment that allows previous layers of colour to show through. A layer of yellow glaze can be painted over a layer of blue and look green. They are great for adding subtle changes in shade and tone, but a glaze can also be painted over an entire painting to unify all its colours.

⫸ MATT AND GLOSS

Acrylic paints naturally appear shiny when dry because they contain plastic resin. Some artists prefer a matt finish, so they use a matt medium to remove the shine. When heavily watered down, however, acrylic will lose its gloss, so you may want to add a gloss medium to recapture some of the shine – or simply to add even more shine to a painting. Both mediums can be applied directly to the surface of a dry painting.

⫸ RETARDER

Retarder slows the drying time of acrylic paint, which is useful if you want to use techniques usually associated with oil panting, such as painting wet on wet. Be careful not to add too much – use about 10 percent of the quantity of paint.

⫸ MODELLING PASTE

Modelling paste comes in light and heavy consistencies and adds more body to the paint, especially to a soft-bodied acrylic, making it form peaks like a heavy-bodied acrylic paint. The choice depends on the texture you want – the light consistency has gentle peaks while the heavy one can form more dramatic shapes.

⫸ SOFT GEL

Soft gel can be added to a heavy-bodied paint to thin it. It can also bulk out a soft-bodied paint, which is especially useful if you are about to run out of that colour.

⫸ TEXTURE

Texture mediums add a tactile quality to the surface of the painting that can be grit like or fibrous as well as impasto.

⫸ FLOW/POURING

As the name suggests, flow/pouring mediums increase the fluidity of the paint. They are great for making paintings in which paint is poured onto a surface. They come in gloss and matt versions.

COLOUR

Understanding colour is essential to painting. After all, applying paint to a canvas is essentially applying colour, and the choices you make in your palette selection will affect many aspects of your painting.

I always tell my students, if you learn to understand and play with colour, you are halfway to making a good painting

Since the vibrancy of colour in acrylic paint is a primary component of its attraction, it makes sense that those using acrylics learn how to use colour, in order to make the most of this. A painting's colour palette can help to portray emotions, give a sense of coolness or warmth, create an aesthetic that is pleasing, exciting, jarring or soothing to the eye – and many other things besides.

COMPLEMENTARY COLOURS

In painting, we divide the spectrum into three primaries (red, yellow and blue) and three secondaries (green, orange and purple). Secondary colours can be made by mixing two of the primary colours, and the primary that was not used to make a particular secondary is known as the latter's 'complementary colour'. For example, blue and yellow make green, which is the complementary colour of red.

Mixing primary colours

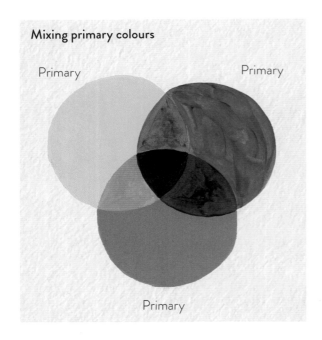

Primary

Primary

Primary

Since before the 17th century, artists have used colour wheels as an aid to understanding and talking about colour. On a wheel, we can see the relationships between primary, secondary and tertiary colours ('tertiaries' are those colours in between the primaries and the secondaries) and divide colours into categories such as 'warm' and 'cold'. A wheel is also a useful way of visualizing the complementary colours – these sit opposite each other on the wheel – as you can see from the example opposite.

Using complementary colours together creates vibrancy in a painting, as the contrast between them heightens the impact of each. If you look at the work of Vincent van Gogh, you will see that he was a great believer in using a palette of complementary colours, especially blues and oranges, and you will be able to see what an impact this strategy can have.

By mixing two complementary colours together, the hue will become darker and more muted, which can create more balance in the painting if it is feeling too intense. If you go too far, however, the result can end up a muddy brown, which might not be the effect you had intended.

* **TIP: The complementary colour pairs are:**
- **Blue and orange**
- **Red and green**
- **Yellow and purple.**

Complementary pairs

COLOUR MIXING

It's worth having variations on the primary colours in your art box to maximize your mixing potential.

By having two reds, two blues and two yellows, you will be able to achieve a much greater diversity of colours than if you had only one of each colour. In theory you should be able to mix any colour you desire from this selection, but there are a few colours that are tricky to make, while offering a good addition to your palette, and these have been noted on the opposite page.

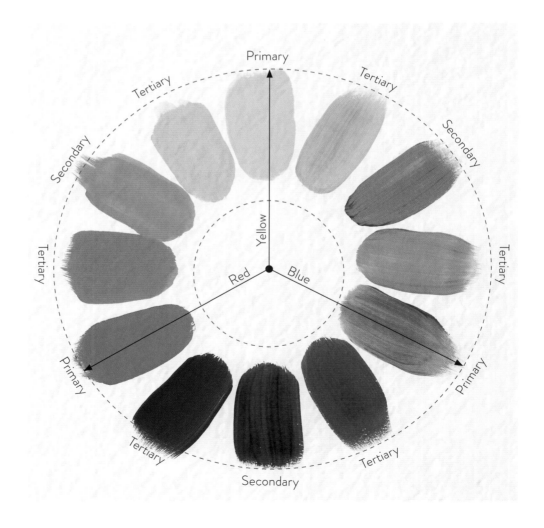

Colour mixing chart

Greens				Oranges		Purples	
Phthalo Blue	Phthalo Blue	Ultramarine Blue	Ultramarine Blue	Crimson	Cadmium Red	Ultramarine Blue	Ultramarine Blue
+	+	+	+	+	+	+	+
Lemon Yellow	Cadmium Yellow	Lemon Yellow	Cadmium Yellow	Lemon Yellow	Cadmium Yellow	Crimson	Cadmium Red
=	=	=	=	=	=	=	=

➤ RECOMMENDED COLOURS

The specific colours I recommend using are: cadmium red and crimson red, ultramarine and phthalo blue, cadmium yellow and lemon yellow – a warm and cool version of each primary colour. I would also add titanium white, burnt umber and black or Payne's grey so that tones can be mixed.

The chart above demonstrates the mixing potential that comes from having two versions of each primary colour – by mixing the variations in different quantities, you will have a huge array of colours available to you. Green can be created not just by mixing blue and yellow but also by adding the tiniest dot of black to yellow, which makes beautiful olive greens – a combination that often surprises people.

➤ OTHER USEFUL COLOURS

Yellow ochre, burnt umber, buff titanium, viridian and sap green are all also worth having in your paintbox, as they are difficult or nearly impossible to make, and they will add to the array of colours and tones that can be made from primaries and black and white.

Colours that are not necessarily needed but will add luxury in depth of colour and glow include: magenta, cerulean blue, cyan blue, deep cadmium yellow and Naples yellow (my favourite). I will also sometimes use pink, purely for pleasure, as it is a fun, contemporary colour that is used little in traditional painting.

CHOOSING YOUR PALETTE

Aside from the sense in which it is a physical object, a palette is the selection of colours you choose for a painting. Laying out all of your colours can be wasteful and can create a pressure to use them just so as not to cause waste. It is useful to think about what you are about to paint and to think of the colours that you will need.

≫→ A REFINED PALETTE

There are a number of strategies for choosing a more refined palette. Some options include: a monochrome palette, with different tones of one colour; a limited palette, which might be just two, three or four colours and white; a complementary palette, based around a complementary pair; or a selected palette of several colours. For example, if you are painting a portrait, you might gather all the colours that are required to make flesh tones, plus perhaps a contrasting hue (such as green) for the shadows. In the example below, you can see that a selected palette could alternatively be quite varied and unrealistic, but the colours are still carefully chosen, and I haven't used every single colour available.

It's a matter of personal taste, but as a guiding rule I never use all three primaries unmixed in one painting, as the result can look jarring. Neither do I use every colour that I have, as this can be garish.

You may form a preference for a select few colours – this is your preferred palette. We are all unique, so get to know what it is that you enjoy seeing and which colours you like to use in your painting.

Monochrome palette

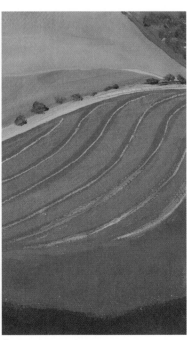

Secondary colours

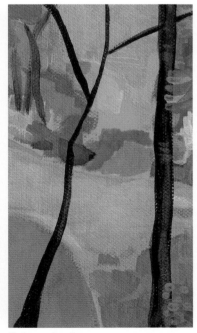

Selected palette

LOCAL VS SYNTHETIC COLOUR

When selecting your palette, you have a choice whether to paint the colours that you see, or to create a different atmosphere and substitute the real colours for different ones.

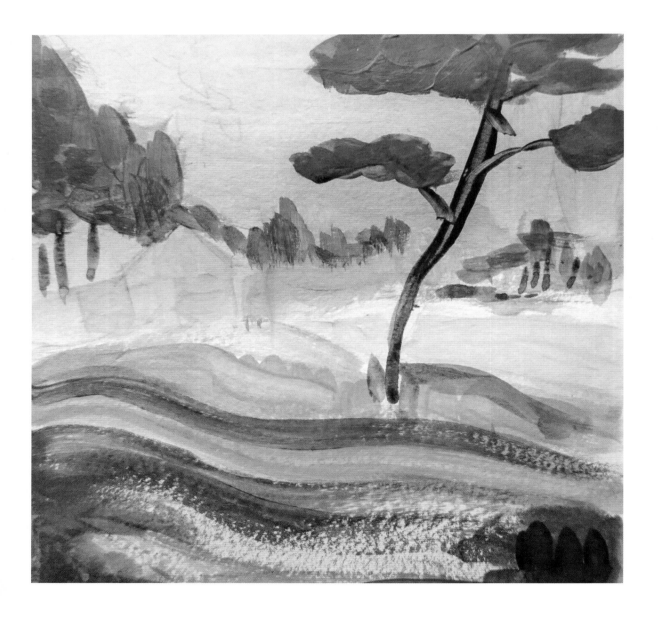

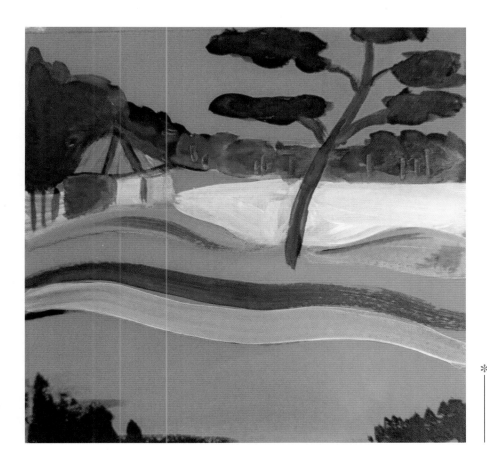

✳ **TIP: You can play with a photo editor on your smartphone or use Photoshop to explore different colour compositions.**

'Local colour' is the colour that something actually is. Using local colour, I would paint, for example, a sky in sky blue, tree trunks in brown and the grass in green. Observation is key to getting your colours right. If painting from a printed image, especially a photocopy, you can place a dot of the mixed colour onto the image to see if the colour matches. The comparison is trickier when painting from real life, but still possible.

'Synthetic colour' is alternative colour from reality. I often use cyan blue or pinks and lilacs for the sky, mauve for tree trunks and blues and oranges for grass. Synthetic colours can be similar to the actual colour but of a different shade, or they can be completely different. You can use synthetic colour to create a surreal, stylized or emotive painting.

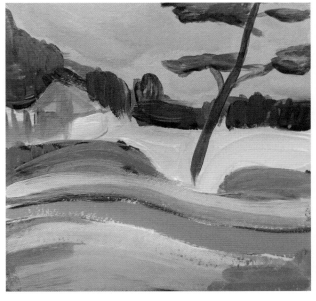

MATERIALS & EQUIPMENT

The materials and equipment you use are as important as the paint and the painting. There is a huge variety to choose from for acrylic painting, and the choices you make here will determine a lot about the outcome of the painting, so it's best to be informed.

This chapter offers suggestions for just some of the things you need to consider. Not everything you need has to be shop-bought; lots of ordinary things around the home that can be utilized or assembled to make customized tools. Be creative.

SURFACES

Acrylic paint can adapt to almost any surface, also known as the support. Here are some of the most common.

⫸ PAPER

Acrylic paper is convenient, since there is no need to stretch it beforehand. I use 360gsm paper as it feels a good weight and can hold a lot of paint and water without it warping. If heavy cartridge paper is used, it is always a good idea to stretch it beforehand to avoid it warping.

⫸ CANVAS

Canvas is an organic material made from cotton, and it comes unstretched on a roll, or already stretched (see overleaf). The fabric surface is very absorbent, so you will probably want to prime your canvas before using it, otherwise the paint tends to drag along the surface rather than moving fluidly across it, and of course you will end up using more paint. Some people enjoy painting on raw canvas – try it yourself on a small piece.

⫸ CARDBOARD

All types of cardboard make a great support for acrylics. Cardboard can be painted on directly or primed first, depending on the finish required. Painting on (unprimed) brown cardboard will cause some colours to appear muted, but it can also be a neutral base colour for a painting. A white or lightly coloured primer can be used to ensure that the paint colour applied on top appears more vivid, and ensures the cardboard is less absorbent.

⫸ ALUMINIUM

Small sheets of aluminium can be found in most art shops. I recommend the sheets that have had their surface prepared with chemicals, which allow the acrylic paint to adhere to it. An aluminium surface will give your painting a glow. It can be frustrating trying to get the paint to stay in place on aluminium, and you must let it dry thoroughly, over two days, before touching it, otherwise the paint may come off.

⫸ OTHER MATERIALS

These can include bed sheets, plastic, MDF (medium-density fibreboard), wood, hardboard, watercolour paper, newsprint and tissue paper.

PRIMING

'Priming' is preparing a surface with an undercoat to make it ready for painting. It seals the surface so it is less absorbent, allowing the paint to slide over it rather than just be absorbed into it. You might also prime to create a surface that the acrylic paint can adhere to.

≫→ PRIMING & STRETCHING CANVAS

When priming canvas I use a ready-made gesso that can be bought in art shops. Traditionally, primer was made from animal glue and chalk, but gesso primers today tend to use other binders instead of animal glue. Cheaper gesso has less chalk content than the more expensive options; which you choose to use is a matter of affordability and personal preference.

A stretched canvas is one that is attached to a wooden frame. I work on canvas that I have stretched myself as well as on pre-stretched canvas. Some people like to work on unstretched canvas stapled to the wall or another surface, then put it onto a stretcher frame at a later date, although it can be tricky stretching a painted canvas. Shop-bought canvases tend to be already primed, but to get a smoother surface, more gesso can be applied and sanded down.

I prepare the surface with three or more layers of gesso, allowing each layer to dry fully in between coats. For the first layer, I dilute some gesso with an equal amount of water – with this ratio, the primer is easier to apply to your absorbent surface. For subsequent layers, I do not dilute the gesso. I use a wide brush (a baker's brush) to apply the primer, starting from the centre of the canvas, working it into the weave of the canvas and painting back and forth with the brush.

In between layers, I use fine sandpaper or wet-and-dry sandpaper to sand the surface. How much you sand depends on how smooth a surface you want to work on.

❋ **TIP: When applying the top layer of gesso, I add in some acrylic paint in the colour I want to lay down as the ground colour of the painting.**

✳ **TIP: Gesso is expensive, but you can make your own primer using household emulsion. The downside is that emulsion has a shorter life expectancy than gesso. It will, however, last for a number of years. To make a primer from emulsion paint, I use four parts white emulsion, four parts PVA glue and two parts water – or one cup of emulsion, one cup of PVA glue and half a cup of water. Mix it all thoroughly and store in an airtight container clearly marked 'emulsion primer'.**

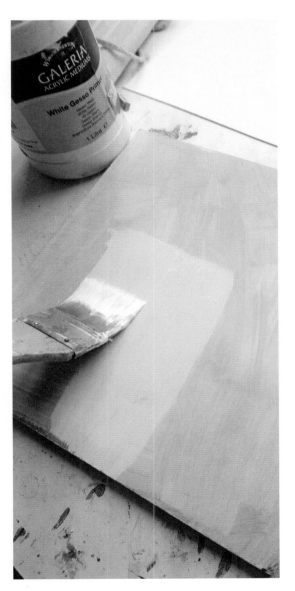

⏩ PRIMING MDF

MDF is a fibreboard made from reconstituted hard and soft wood compressed together with a resin binder. It is advisable to use pieces that have already been cut to size as the dust is a health hazard. When using MDF, it first of all has to be sanded using sandpaper down to create a smooth surface. This should preferably be done outside or whilst wearing a mask. Primer/gesso is applied the same way as it is to canvas, but this time it has to cover the front, back and all the sides of the MDF, otherwise the board will warp. To apply the gesso, I often use a small paint roller as it leaves no brushstrokes. You can also use wood primer from a hardware store.

During the first few coats of primer, you will notice that tiny fibres of wood rise to the surface – you need to use a fine sandpaper over the entire surface that is to be painted in between layers.

MDF is an affordable and freely available surface to paint on. I avoid using it for a painting larger than 4ft as it does tend to warp. The bigger the sheet of MDF, the thicker it should be to avoid it bending.

It is safe if precautions are taken. The fine dust that is created when cutting or sanding down MDF can cause respiratory problems and is a carcinogen, so always wear a mask, and cut and sand outdoors if possible.

BRUSH SELECTION

It can be daunting choosing paintbrushes, and since they can be expensive, you don't want to choose the wrong ones. These pages give you an overview of the different types of brushes and the marks they make, so that you can pick the ones you need.

Synthetic brushes are ideal as they hold acrylic paint well and allow the paint to glide on. Bristle brushes will make the acrylic paint drag a little and this is reflected in the brush mark, which will have more texture. I avoid sable brushes with acrylics as the paint tends to destroy them.

 All brushes come in various sizes, and the size should reflect the size of the area it will be painting – larger brushes for laying down large areas, and smaller brushes for details. I like to use a variety of sizes in all my paintings for the variety of marks this tends to generate.

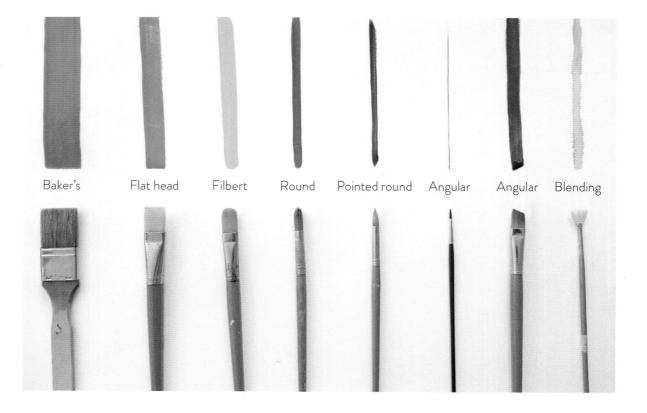

Baker's Flat head Filbert Round Pointed round Angular Angular Blending

TIP: Acrylic paint, when dry, will not come out of your brush, so always rinse your brushes straight away after use. At the end of a painting session, wash all used brushes in warm soapy water – I use olive oil soap.

TIP: To soften my brushes, I often treat them with hair conditioner overnight. Just rub it into the bristles and lie the brush flat, then rinse thoroughly in the morning.

Spotter brush

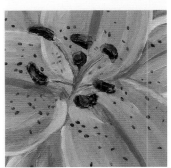

➤ BAKER'S

Named after their original purpose of applying milk or egg to the surface of dough when baking, these wide flat brushes are great for priming and laying down a wash of colour. They are affordable and durable.

➤ FLAT HEAD

These brushes come in a range of bristle lengths. There is more control with the shorter ones, where the bristles are almost square. These brushes can give a nice, sharp line, and are good for coverage of larger areas. You will notice that their marks give a hard edge.

➤ FILBERT

The name refers to the shape of the brush, which is rounded like a hazelnut. It has a rounded, flattened tip. These brushes are good for coverage and blending colours together – when making a mark, there are no hard edges, and so the paint strokes have a softer, rounded look and blend together.

➤ ROUND

The tips of these brushes can be quite round or have a slight point. These are classic school paintbrushes. They hold paint well and, as they are round, they give a consistent line whichever way they are moved.

➤ POINTED ROUND

The tips of these brushes are very fine, therefore they are great for delicate lines and detailed work.

➤ ANGULAR

The bristles at the tips of these brushes are cut at an angle. This makes these brushes excellent for getting paint into corners and for filling in areas.

➤ FAN/BLENDING

These are good for smoothing out brush marks and blending. They can also be useful for painting foliage in smaller paintings, as their marks give a good imitation of leaves.

➤ SPOTTER

These are small brushes that have blunt ends, as opposed to sharp points. They are great for painting spots and lines, and highly detailed work.

OTHER TOOLS & IMPROVISED TOOLS

You can use virtually anything to paint with, not just brushes. You probably already have done without even realizing it. Perhaps when you had to wipe a bit of paint off, you used your finger or a damp cloth; or possibly you've used a hairgrip to scratch into the paint.

Using different tools allows for a greater variety of mark-making and for more experimentation, from which happy accidents can occur.

➤➤ HERE IS A KIT MADE UP OF SOME TRADITIONAL TOOLS, AND SOME THAT ARE IMPROVISED:

- Palette knives

- Washing-up sponges

- Rags

- Damp cloths

- Sticks/bamboo pieces

- Feathers

- Old credit cards

- Brush tied to a stick

- Two brushes nailed together

- Fingers in a sock

- End of the brush handle

- Nails

- Household brush/mop for very large paintings

Painting is not just about putting a layer of paint on a surface; sometimes the process involves putting it on and removing it several times, by scratching it away or wiping it with a damp cloth. For each layer, some of the paint will stain and not come off – this is all part of the process in which interesting marks are made.

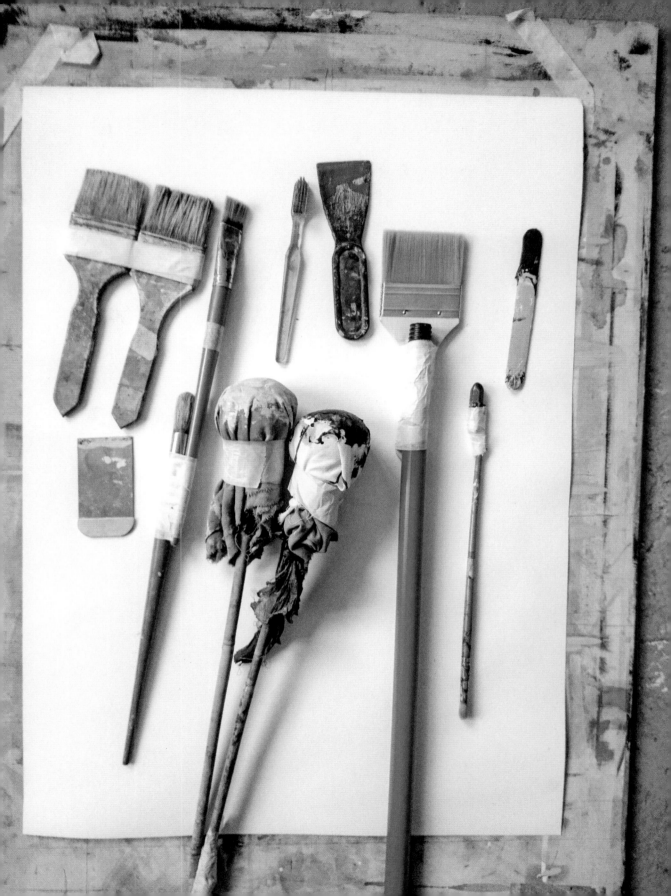

TYPES OF PALETTES

There are many types of paint palette. Essentially, a palette is a non-porous surface that you can put paint on and mix.

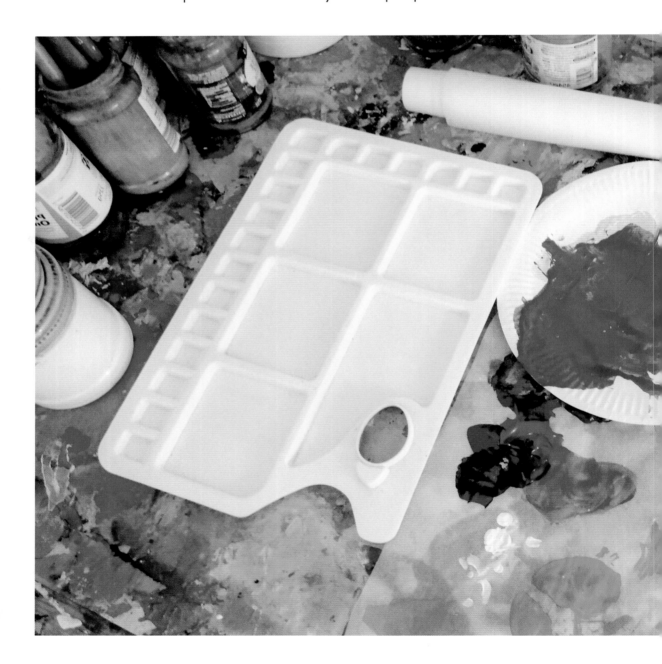

✳ TIP: Keep your palette on the same side as your dominant hand. Doing this will mean you don't have to lean over your painting when you need to mix new colours.

Apart from the items below, you can also buy disposable paint palette pads, but I do not find them very useful as they come in a predetermined size. I recommend using a palette of roughly a similar size to your painting.

➤ GLASS AND ACRYLIC GLASS

Glass and acrylic glass (such as Perspex) make wonderful palettes, as their smooth surfaces allow for easy mixing. Because they are clear, you might want to place them over a sheet of grey card for a better perception of the paint colours. You will need to clean them at the end of a painting session.

➤ PLASTIC MOULDED PALETTES

Plastic moulded palettes have defined areas so that mixes don't contaminate each other. These palettes need to be washed thoroughly after a painting session, because dried pieces of paint can flake off and mix into new paint.

➤ BAKING PAPER/GREASEPROOF PAPER

Baking paper/greaseproof paper is great for making palettes. It can be cut to the size that you need. You can write on it in pencil, noting how you made a certain colour. It is semi-transparent, so it can be laid over a table or grey card so colours can be seen more clearly. I use masking tape to attach it to my palette table. These paper palettes can also be kept and put into a sketchbook as a reference for the colours you used in a specific painting.

➤ PAPER PLATES

Paper plates are useful when used as an aid to a larger palette, especially when you are mixing a wash or a larger quantity of paint. They are also handy for when you want to work up close to a large painting without having to keep turning away to use a larger palette. They can be used several times without needing to be cleaned, and you can keep them for reference.

➤ STAY-WET PALETTES

'Stay-wet' palettes are sold in art shops and are basically plastic containers designed to store mixed paint and keep it wet for a few days. Since acrylic paint dries so fast, you can end up wasting a lot, so these are a great idea. However, they are expensive. I will be showing you how to make your own stay-wet palette over the page.

MAKE YOUR OWN STAY-WET PALETTE

As already mentioned, stay-wet palettes are great for reducing paint waste. They stop paint from drying out, which is especially useful if you have mixed a large quantity of paint or a small amount of a specific colour and need to stop painting for the day. You don't need to buy an expensive, purpose-built one from a shop, however – you can easily make your own stay-wet palette.

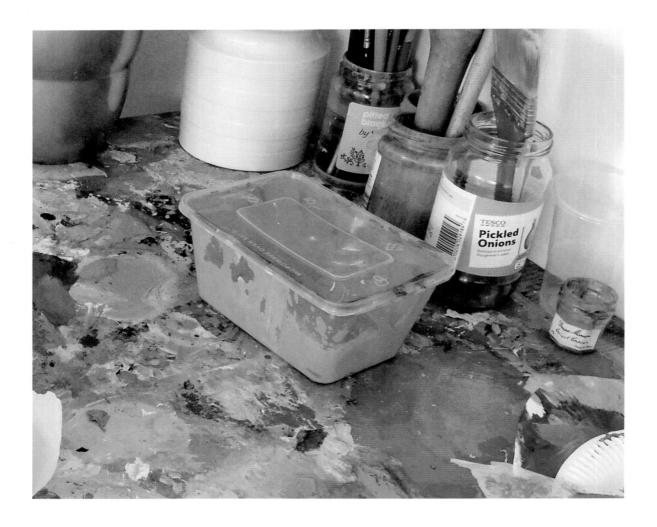

You will need: a shallow sealable plastic container, paper towels or kitchen roll, baking paper/greaseproof paper and masking tape.

{1} Find an airtight container of a suitable size. Containers for storing food are ideal. The aim is to create a moist environment inside the container. {2} Place a folded paper towel or piece of kitchen roll at the bottom of the container. Add about a tablespoon of water to the paper towel. {3} Cut out a piece of baking paper that will fit into the container and some way up the sides. To get the size exactly right, you can draw around the lid and then add another couple of centimetres (or approximately an inch) all the way around. You mix the paint directly on the baking paper. {4} When you wish to store it, you simply transfer the paint to the container, and put the lid on. {5} I write the name of the colour and sometimes what I used to make the colour onto masking tape and place this on the lid.

* TIP: When using acrylic paints, it is often a good idea to keep a misting sprayer nearby (the kind that is used to spray mist onto plants). If painting over several hours, just spray the mist over your palette to stop the paints from drying out.

{1}

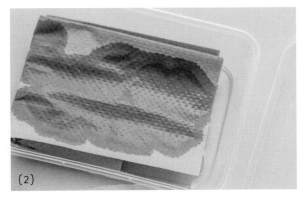

{2}

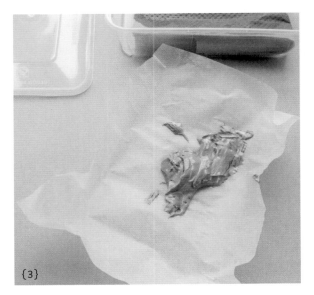

{3}

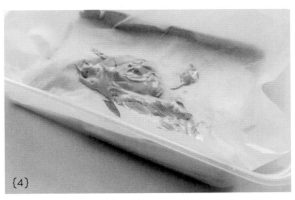

{4}

That's all there is to it. You can put different colours in different containers or use a larger shallow container to put a few colours in. They should remain usable for a few days.

EASELS, BOARDS & WALLS

The support for the canvas or paper is often guided by the availability of space. When I was using my kitchen as a studio, I had nowhere to store an easel, so I made use of the kitchen furniture to prop up my board. When working on large sheets of paper, I would tape them to the walls in my hallway. Now that I have a studio, I can use the walls and have space for an easel.

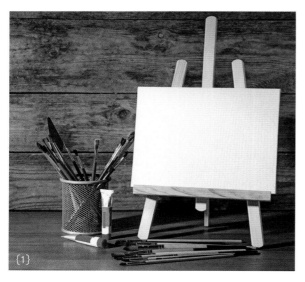
{1}

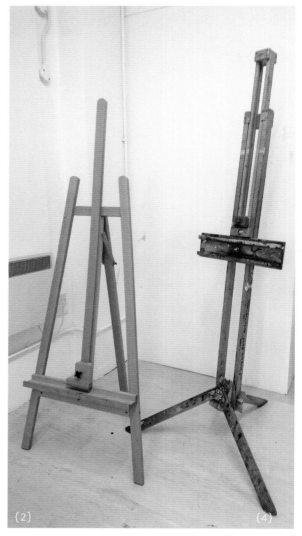
{2} {4}

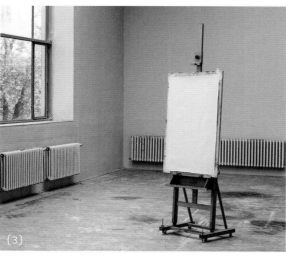
{3}

⨠ EASELS

Easels can be used to support canvases and boards. When using an easel, the middle of the painting should be at eye level. They come in many different styles and sizes, but I am going to look at just four main types:

{1} **Table-top easels are a great investment, especially if space is a problem. Smaller boards and canvases will fit on this small easel, which folds down flat and is easy to store.** {2} **The A-frame easel can stand flat against a wall or under a bed. They are not so good if you are tall, as they only adjust to a certain height, which may not be high enough. When buying an easel, always check its maximum height is suitable for you.** {3} **The large studio easel is a professional easel on wheels, and it is expensive but worth it. It is sturdy, adjusts to all sizes, it can easily be moved around the studio, perhaps following the light, but it is less easy to store. It really needs its own dedicated space.** {4} **The large radial easel is the traditional easel that you tend to find in art schools. They can fold away but are usually left assembled. These adapt to all heights and are strong enough to hold large paintings. For me, their downside is that the low trio of legs at the base makes for a tripping hazard.**

⨠ BOARDS

Boards can be bought ready-cut from DIY stores. You can tape paper or canvas to them or paint directly on them. I like to use two sizes: A2 (42 x 60cm/16½ x 23½in) for smaller works and A1 (60 x 85cm/23½ x 33in). They can be propped up on tables, worktops or placed onto an easel.

⨠ WALLS

Of course, this won't be appropriate for everyone, but now that I have a studio, walls are my preferred place to paint a canvas. I have a nail system that allows me to reach the tops of large paintings, and not injure my back when painting the bottoms, and I can move the canvas up and down. If I get paint on my walls, I regularly paint over them in white emulsion so as to maximize the light.

MAKING PAINTINGS

The processes of starting, continuing and completing a painting can be punctuated with moments where you feel stuck. The white space still left on the canvas can feel like a rebuke, and often, all you can see are the things you could have done better.

Before we get into the tutorials, the next few pages arm you with a few techniques you can use to make completing a painting less of a daunting task. I will also share some advice to help you to evaluate your work without becoming self-critical.

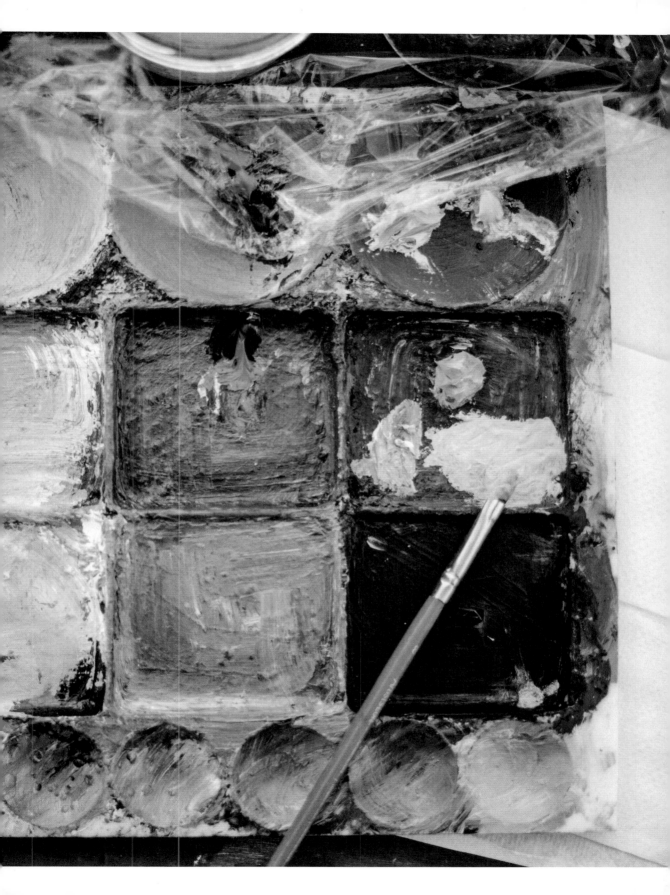

STARTING A PAINTING – GROUNDS

A ground refers to how a surface has been primed/prepared; for example, with gesso. A ground colour is the first application of paint on the prepared surface, which can be white or coloured.

Base colours for a bright painting

Base colours for a sombre painting

I prefer to paint on a coloured surface, firstly, because this stops me from just trying to fill in all the white spaces like I'm painting by numbers. But mostly, it adds to the joy of painting and playing with colour.

The ground colour can be applied as a wash – that is, a very watered-down paint with a consistency like watercolour – or as a thicker, more solid and less diluted opaque ground. The latter will show through any transparent lighter layers, which can add depth to a painting; this ability to build up layers is a great advantage of acrylic paints.

I use a baker's brush or a wide flathead brush to paint the ground. When choosing a ground colour, I think about the image I want to create, and find a contrasting colour. I often use pinks, oranges, yellows, reds, ochres and lilacs as my base, because they lend a painting brightness. Using greens and blues, on the other hand, can dampen down an image and give it a colder, more sombre look.

My choice of ground colour suits my preference for a warmer, brighter final image, but remember that this is a personal choice – you must do your own experiments to find out what ground colours will suit your painting best.

⇛➔ THINK ABOUT WHAT IMAGES YOU ARE DRAWN TO AND WHY:

- Is the style abstract, figurative or somewhere between the two?

- Is the colour a main element in the image, or a main factor of why you like an image?

- Are the marks loose or tight? Are they small, precise and detailed or large and gestural?

- How do you feel about the subject matter – do you tend to prefer still-lifes, landscapes, portraits? And do you prefer to see these done in an illustrative way or an abstract way? With a contemporary feel or a traditional one?

GAINING PERSPECTIVE

When painting, it's easy to become frustrated and over-critical, or to lose sight of what you are painting. Rather than giving up, or making hasty decisions, step back and engage your objectivity: take some time to reflect and evaluate what you have done so far in the painting, and where you want it to go.

There are several ways to do this:

⫸⟶ OBSERVATION

A good first step is to actually create some physical distance between you and the painting, and to look at it from farther away. Remember that you are standing very close to a painting when you are making it, focusing on certain details, but the finished thing will be viewed from farther away and viewed as a whole, when it's hanging on your wall. Alternatively, you can try looking at your painting in a mirror. Like changing your distance, this will let you see it from a new perspective, and as a whole that is working or not working as an entirety, rather than as a series of separate parts, some of which you are more or less pleased with.

⫸⟶ REFLECTION

This refers to the ability to think about what you have done so far in the painting, and where it is going, taking time to consider your precesses, your strengths and weaknesses. It can be useful to take regular photographs of your work as it progresses, which you can then look back over. Not only will they help to remind you of what you did at each stage, but you can also look back over the various stages of a painting to assess what worked and what did not, and what different decisions would have resulted in a better outcome.

⫸⟶ TACKLING CREATIVE BLOCK

Creative block is an awful thing that affects us all. When it occurs during the middle of a painting, it really is time to put down the paintbrush before you destroy what you've done so far. Try the ideas above and opposite, or just start a new painting. I often have several on the go. It can help to make a quick sketch painting, just to loosen up your imagination again. Sometimes, I simply change a colour in my palette, and I am off painting again.

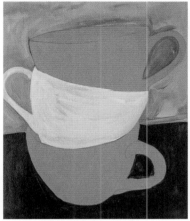

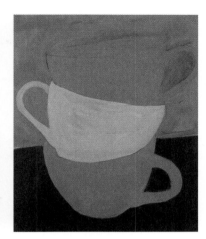

First checking the tonal variation

After tonal variation has been adjusted

⇥ COMPOSITION

Line, form, tone, shape and colour are all part of an image's composition. You can use a camera and image editor (your smartphone is a useful tool that has both in one) to play with these elements and assess it objectively. I will take a photo of my work and then use a photo editor to change it to greyscale – this shows me if I have good tonal variation, including very light, very dark and mid-tones. The cropping tool is also useful for exploring if a painting would look better if its edge was in a different place. You might find that an image looks better cropped in smaller and to another format, such as portrait format to a landscape format.

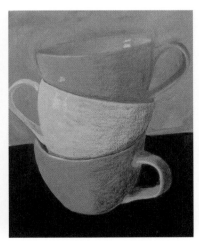

TUTORIALS

The tutorials in this section have been divided into themes to allow you to explore using acrylics through a number of different approaches.

We begin with the physical aspects of the paint: playing with its qualities using different mediums and techniques. We then move on to tutorials that get you practising aspects of using colour, line, observation, scale and mixed media, to get you pushing your paints in ways you've never thought about, while at the same time learning the skills that will enrich your artistic practice in any medium.

TECHNIQUE, STYLE & TEXTURE

ABSTRACT PAINT POURING

Pouring medium can be added to acrylic paint to improve its flow, allowing it to run freely. By mixing different colours in separate cups and adding pouring medium, you can create a vibrant abstract piece. This is a fun (and very messy) exercise that allows you to play with different colour combinations – you could use a tried-and-tested combination you already know works well, or your could use this tutorial as an opportunity to try out new combinations, free to focus on the colour without the pressures associated with making figurative paintings.

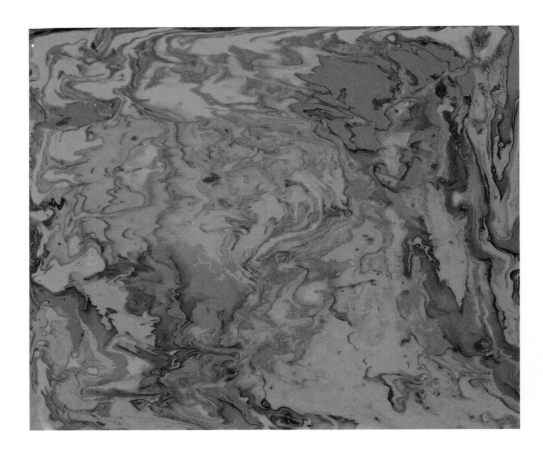

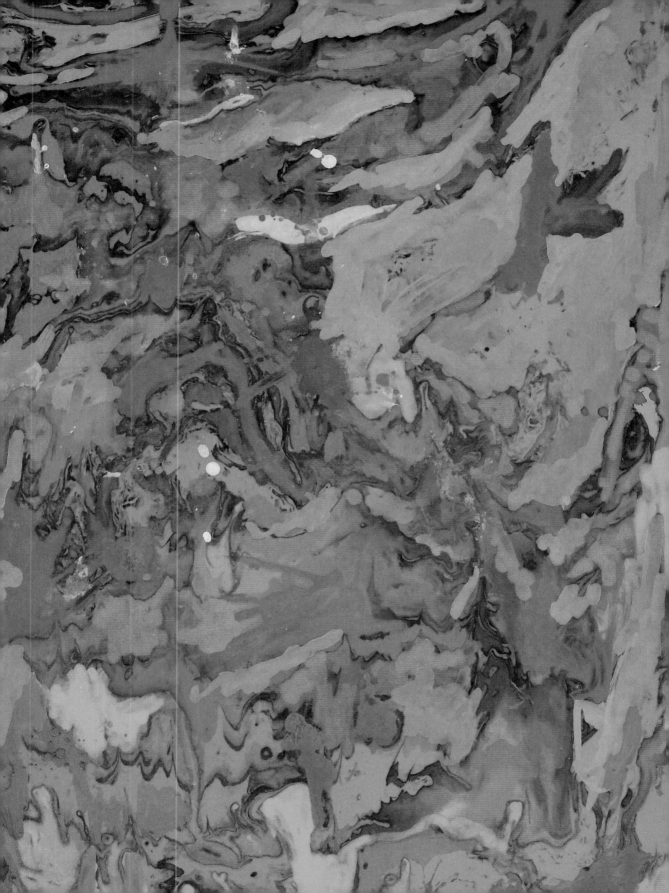

It may take several attempts to get this technique right, but good results will come if you persevere. Work on a small scale, on a surface such as a stretched canvas, board or piece of MDF. Do not use canvas board for this, as the lengthy drying process causes the ends of the canvas board to curl up. This is an incredibly messy technique, so I recommend wearing gloves and putting a protective covering on the floor, or working on a large old drawing board. I placed my canvas flat on top of two rolls of tape. It's a good idea to raise your surface because paint will drip down the sides, causing it to stick to whatever it is resting on.

You will need: **Cups for the paint, pouring medium, stick stirrers, board or stretched canvas, two rolls of tape or a wire rack and latex gloves.**

{1} **Mix four or five colours of paint that you think will work well together. I have used cadmium red, phthalo blue and white, pink, turquoise and orange. I used about 50:50 of pouring fluid to paint medium, but the right ratio will depend on the brand of medium you buy. If unsure, it's better to use more medium than paint, as, if the mixture doesn't flow, it will be wasted; alternatively, try adding the medium a little at a time until you have the right consistency. Raise your canvas or board off the surface using something reasonably sturdy, appropriate to the size of your support, and on top of a dust sheet or newspapers if you need to protect the surface underneath. {2} Pour your first two colours in a zigzag fashion. {3} Lift up the board or canvas and tilt it back and forth and side to side, allowing the paint to flow and the colours to run into each other. {4} Pour your next two colours onto your support. {5} Tilt the board again, repeating step 3. {6} Add your final colour, repeat step 3 once more, and leave the painting to dry for three days. As your abstract painting dries, you will find that the colours disperse a little more.**

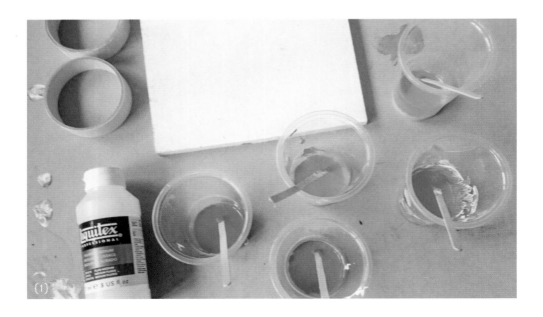

✳ TIP: The piece needs three days to dry, so put it in a place where you know it will not need to be moved, and where dust will not fall onto it.

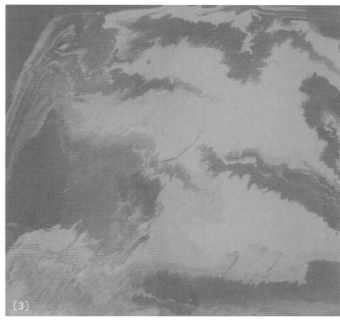

{3}

{2}

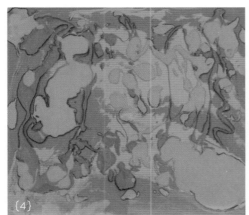

{4}

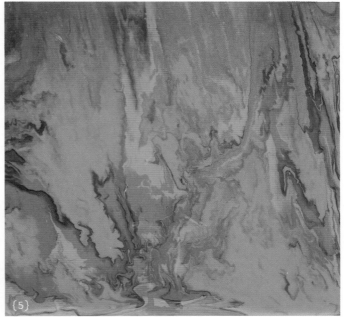

{5}

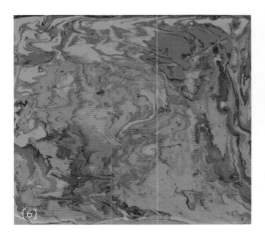

{6}

✳ TIP: Experiment not only with different colour palettes but also with different amounts of each colour in a given combination.

GLAZES – SUNSET

Sunsets can feel like a clichéd subject; however, the challenge of capturing the subtle gradations of light in a sunset sky offer a good opportunity to focus on the effect of using glazes. A glaze is a very thin, translucent layer of paint that lets some of the colours beneath it show through. I started with a coloured ground, then applied a series of glazes, and finished with thicker paint. Your choice of yellows is quite important here: I used a deep cadmium yellow, a cadmium yellow and a lemon yellow. This combination creates an authentic sunset glow.

* **TIP: Try different colours instead of magenta, and you will create a completely different sunset.**

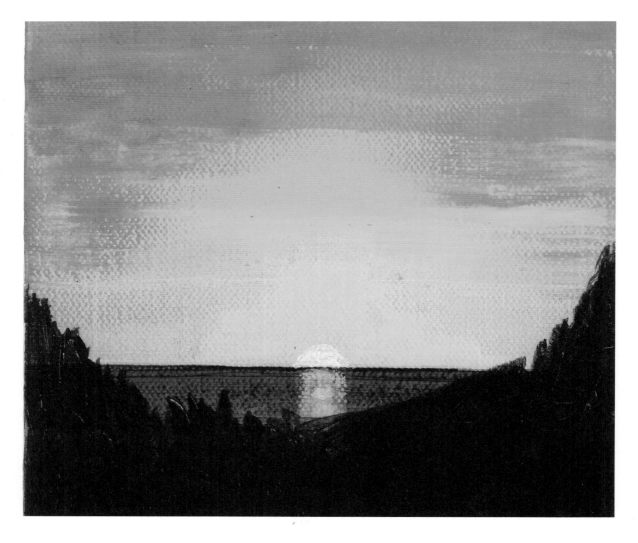

{1}

{2}

You will need: **Canvas, acrylic paper or board, a flathead brush, a pointed brush and a glaze medium.**

{1} **Paint your support with a ground colour** – I used deep cadmium yellow. Mix a darker colour, such as a purple, and add glaze medium – how much depends on how transparent you want your colour; I use one part of each. Paint a band at the bottom of your canvas for the sea. Using a damp cloth, wipe away an area below where you will position the sun, back to the ground surface, to suggest the reflection. {2} Mix some lemon yellow with glaze medium. With a flathead brush, paint a strip along the horizon. Above this, do the same with a band of cadmium yellow, and above this, a band of orange – finishing with a band of magenta. As the glazes will still be wet, they will gently mix together where the bands meet and it will start looking like a sunset. {3} Add more of the magenta glaze around the semicircle of the sun, working the brush only in a horizontal direction across the sky. With a pointed brush, add some undiluted lemon yellow paint along the horizon around where the sun is to be. Allow to dry. With a pointed brush, paint the sun with titanium white. {4} Paint the sun's reflection with lemon yellow. Add a purple glaze over the sea to darken it more. Mix a dark green, purple or blue, and thickly paint the foreground. This will add solidity to the closer elements, as well as making the sun appear brighter in contrast.

{3}

{4}

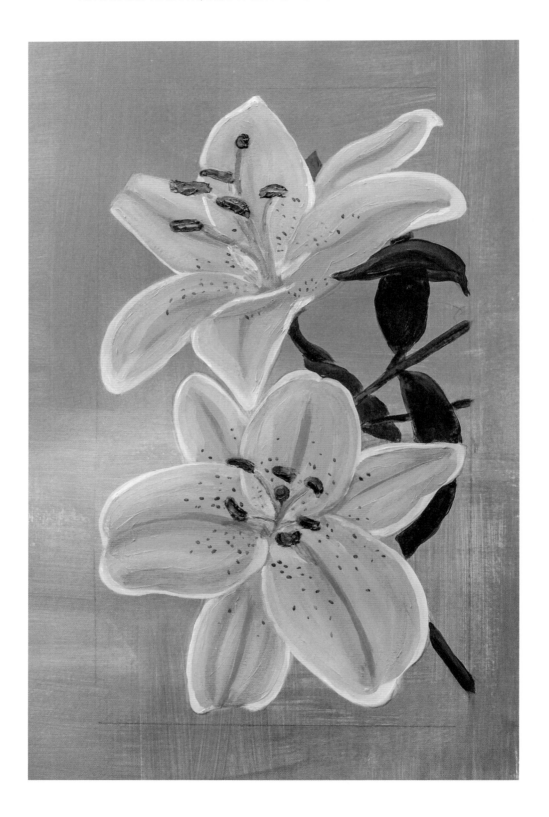

IMPASTO – LILIES

Impasto is a technique where paint is applied thickly to a surface, so that the brush marks are visible and some of the paint is raised. It can be achieved with undiluted heavy-bodied paint or by applying a thickening medium such as impasto paste.

 I have chosen to demonstrate this using lilies because you can use the impasto technique to make the stamen on the flowers really stand out. Impasto does not have to be extreme and applied all over; it can be used to raise certain features of the painting. In the lily, this highlights the contrast between the smooth petals and the textured stamen, giving a more realistic effect.

You will need: **A sheet of acrylic paper, impasto medium, a filbert brush, a baker's brush, a pointed brush and a spotter brush.**

{1} **Use the baker's brush to paint a split wash. I have painted the top half of my paper purple – a mix of ultramarine and crimson red – and the bottom half green (I used ultramarine and cadmium yellow). When dry, lightly draw the outline of the lilies. Use diluted white paint to paint in the petals, carefully leaving a space where you will paint the stamen.**

* TIP: Some people like to
 use a palette knife to paint
 impasto. If you choose to,
 be sure to mix plenty of
 paint, because while a
 brush spreads the paint
 out, a palette knife shapes
 the paint texturally,
 therefore using more paint.

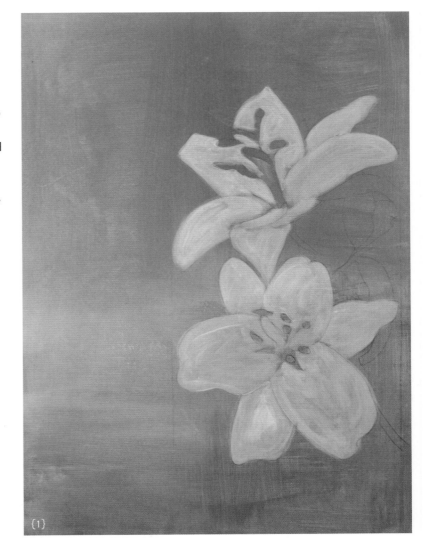
{1}

{2} Mix a dark green and a blue-green for the leaves and stems. I used ultramarine blue and cadmium yellow. Mix a light yellow-green using cadmium yellow, white and a touch of ultramarine, and paint in the stalks of the stamen. This part of the painting is just marking out where everything is with colour. {3} Mix crimson red and white to make a deep pink – leave this mixture undiluted. Apply the mixture with a filbert brush over the petals and allow to dry. With a pointed brush, paint the white outline of the petals with an undiluted white. It doesn't matter how wide you make this outline at the moment because this will be corrected in the next stage. {4} Mix the deep pink mixture with white paint to make a slightly lighter pink. Apply this undiluted to the sides of the petals, leaving the first, deeper pink layer visible as a line through the middle of the petal. Paint slightly over the white edges following the curve of the petal. {5} Make an even lighter pink by adding more white to your mixture. Use a filbert to paint the very edge of the petals – this will add more tone, which helps give shape to the petals. Mix orange and ultramarine with some impasto paste and add this to the ends of the stamen with a small pointed brush. {6} Make a purple glaze using glaze medium, or a wash, from ultramarine blue and crimson, and use a filbert brush to add this where there are darker tones on the petals. Use the spotter brush or the tip of a small pointed brush to add deep pink dots to the petals. Add more light green to the stalks of the stamen, and finish by adding thicker paint to the leaves and stems.

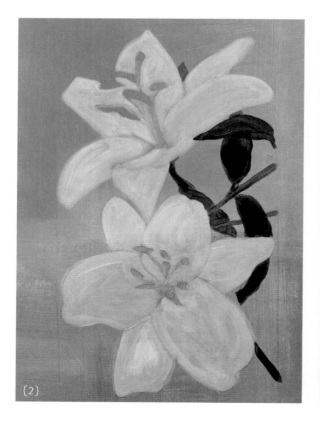

{2}

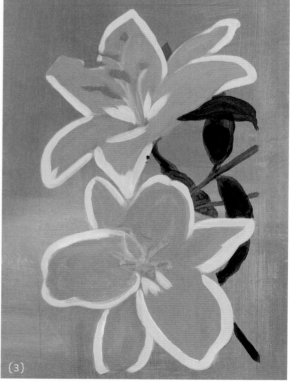

{3}

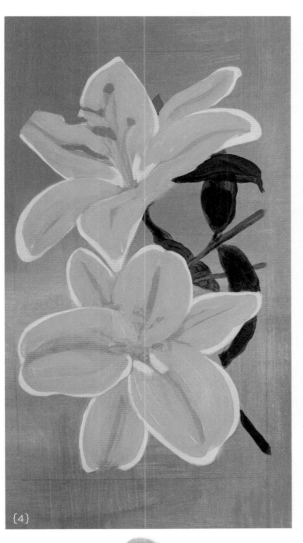

{4}

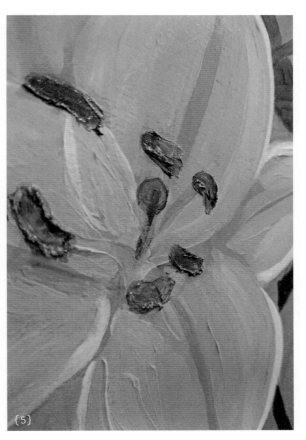

{5}

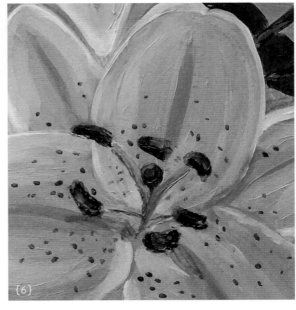

{6}

SGRAFFITO – POPPY HEADS

'Sgraffito' is the technique of scratching off or removing paint to reveal a layer beneath. As well as scratching, you can also wipe away paint while it is still wet. In this exercise, I will be doing both.

This technique means you need to think ahead about the colours that you want to be revealed, as these will be applied first.

Sgraffito works best on board or canvas as a painting surface. Paper can be used, but it can tear, as well as being very absorbent, meaning that the top layer often dries too quickly to be removed.

As the image is made by scratching, the lines you make will have a rougher appearance – do not expect them to be neat.

You will need: A canvas or board, a broad flathead brush and a pointed brush, and a pointed implement for scratching away the paint – I use my old worn-out paint brushes; when the fibres are removed from the tip, the metal casing makes a great scratching tool.

{1} Paint the canvas or board in a ground colour using the wide flathead brush. I have chosen a deep cadmium yellow – you can make this from cadmium yellow and a touch of cadmium red. Allow to dry. {2} Make a line drawing of the image you want to scratch into the painting. Now mix the second colour you want to use, which will be the main colour of your subject. I've mixed a burgundy from ultramarine blue and crimson red, with a larger quantity of the red. Mix water with this paint so that it is fluid like a wash, and use the wide flathead brush to paint this over the entire surface. Before it is dry, scratch in the outline of your subject with your pointed implement. {3} Remove the paint from around your subject using a damp cloth. When the paint is nearly dry, wipe or scratch away highlighted areas. I've wiped away the areas around the poppy heads and scratched away highlights on the stalk. {4} Add a third colour: I've painted a narrow band of green at the bottom, suggesting grass. Allow to dry. {5} Next, apply a final, graded layer of paint using a similar but darker colour to your first (background) colour – this gives your image extra depth. Begin at the bottom in this second colour and work upwards, gradually lightening it by adding more of the first colour. I've used a transition of orange to deep cadmium yellow. Before it dries, scratch in some foreground detail (here, the grass) using the end of the pointed brush. The gradient will give tonal difference while the paint will sink into the scratches, giving a balanced colour overall.

{1}

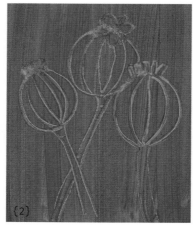

{2}

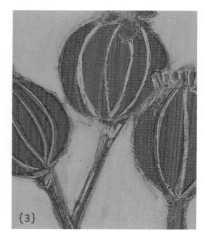

{3}

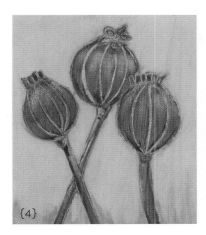

{4}

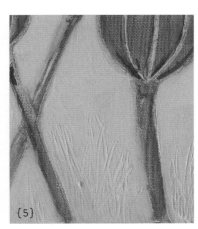

{5}

* TIP: While the surface paint is still wet, you can use a damp pointed brush to draw the image before scratching. As the paint is still malleable, you will be able to remove paint to make a paint drawing.

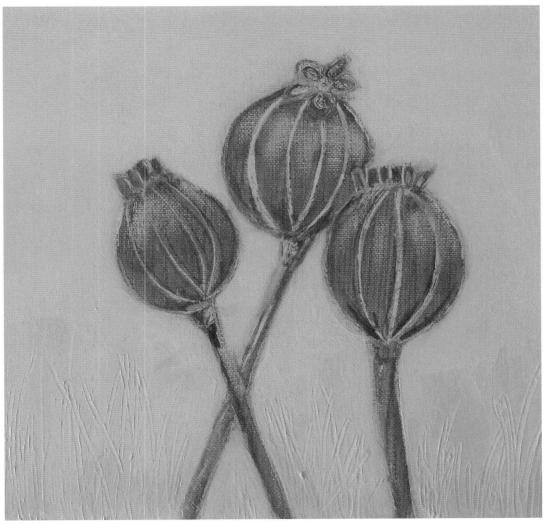

POINTILLISM – MEADOW

Pointillism is a painting technique that branched off
from Impressionism. It involves the application of
paint in small dots, with little (if any) blending on the
canvas. This means that much of the colour mixing
takes place in the viewer's eye; when done well, this
can result in paintings that seem more vibrant than
those that use traditional mixing techniques. Georges
Seurat used this technique with great effect.

➤ USING ACRYLIC PAINT PENS

I have used acrylic paint pens for this exercise (over
a painted ground colour). Acrylic paint pens are
available in a wide range of colours and nib sizes, and
they are useful for when you want extra control.
Alternatively, you can use paint and a pointed brush or
the rounded tip of a filbert brush for this exercise.

I started the image with a ground colour that would eventually merge with the colours I was using for the dots. As an alternative approach, you could use a complementary colour for your background.

You will need: **Acrylic paper, board or a canvas, a baker's brush for painting the ground, and a selection of acrylic paint pens or a selection of paints and a filbert brush and a pointed brush.**

{1} **Choose your ground colour and paint this onto your surface using a baker's brush. I used phthalo blue lightened with white. Allow to dry. If you want, you can draw the basic outlines of your image lightly with a pencil before you paint. Choose an area to start placing the marks. I started with the sky and worked my way down.** {2} **Using a mid-tone green, a darker green and a darker blue, such as ultramarine, add the treeline of the meadow. This will give a sense of scale and perspective to your image, as well as provide contrast to set off the brighter meadow and sky. The trees can be loosely defined by applying lighter green to their tops and the darker green and ultramarine to the shaded areas.** {3} **Fill the entire image with dots — you can let some of the blue ground show through. Use a balanced mixture of light and dark tones. Once the whole area is filled, you can start adding flowers in the background first.** {4} **Fill the meadow with flowers, adding larger, more detailed ones at the front and smaller ones farther back.** {5} **Some of the flower colours will not show up brightly on top of the green meadow. For these you can put down white dots first, and when those white dots are dry, you can add the colours on top (see previous page).**

* **TIP: By dotting blue and then yellow over the top, and next to each other, the dots will appear to be green.**

{1}

{2}

{3}

{4}

{4}

POP ART – PORTRAIT OF A LADY

This tutorial is based on the screen prints of Andy Warhol. Here we will look at breaking up an image into simple shapes using the vibrant colours that were typical of the Pop art movement. The process of screen printing uses acrylic paints mixed with a medium, so even though we're painting not printing, the end result will have the same impact as Warhol's prints.

If you're struggling to break your image down into shapes, try working from a photo. Look for an image-editing app or a website that offers a 'posterize' function, and apply this to your photo.

Choose four colours and assign each colour a part of the image, designated by a tone (the colours do not have to match the tonal value). This is a really good way of learning about which colours work well together for a big impact.

I made one large image and several smaller studies of the same image in different schemes, which, when put together, make a great, classic Pop art piece.

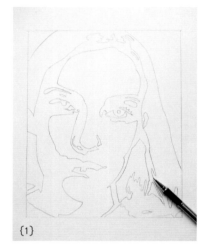

{1}

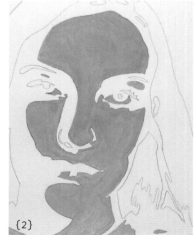

{2}

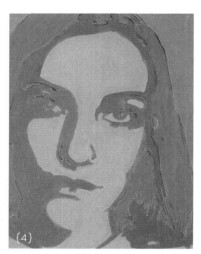

{3}

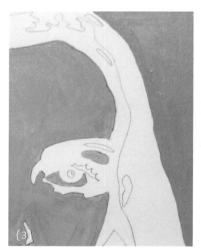

{4}

You will need: **Acrylic paper, a pencil, a spotter brush, a filbert brush and an angular brush.**

{1} Draw the outline of the face in pencil, breaking it down into three tonal areas, with a fourth for the background. {2} Paint the main area of the face in a colour of your choice. I chose a deep cadmium yellow. Use a filbert brush for coverage, and an angular brush for the tricky outlines and corners. Use the spotter brush on the smallest, fiddliest areas. {3} Now paint the background – I used a turquoise made from phthalo blue, lemon yellow and titanium white. {4} Next, fill in the hair. I've used magenta, which is quite a translucent colour, so I used it completely undiluted to get a depth of coverage. For the final tonal area, the shaded areas of the face, I used purple mixed from phthalo blue and cadmium red. {5} If you want to make your own homage to Andy Warhol, make four small studies in different colour schemes. Place these together in a square.

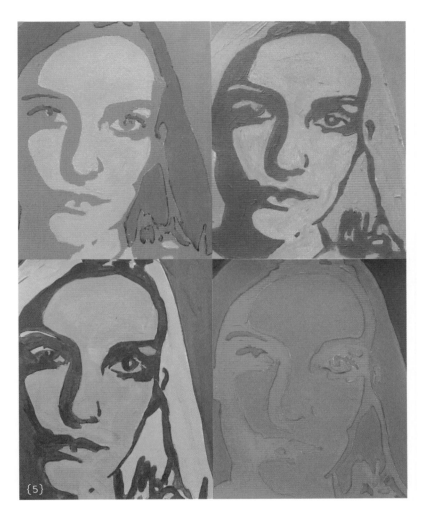

{5}

* **TIP: Use the paint straight from the tube or with very little water to get a solid paint effect similar to screen printing. Warhol's prints were always slightly different from one another, so don't try to make perfect marks either – there is room here for differences that add personality.**

COLOUR

COMPLEMENTARY COLOURS – SNEAKERS

✳ **TIP: You can add definition at the
end by going over the highlights
and adding darker tones to the
inside of the eyelets.**

By using complementary colours, you can produce a really effective
painting. For this project, I've used red and green and added white.
Green is a receding colour, while red advances forward, so I have mixed
ultramarine and lemon yellow green for a green background and used
cadmium red (pink when white is added) for the highlights and parts of
the sneaker that I want to stand out.

 Although this exercise uses only two colours, a range of tonal values
can be created. When red and green are mixed together, more muted,
darker tones will be achieved. When diluted to various degrees, these can
be used for the shadows: watered down to make the lighter shadows, or
mixed without much water to produce a darker, more solid tone for the
heavier shadows and the dark lines on the shoe.

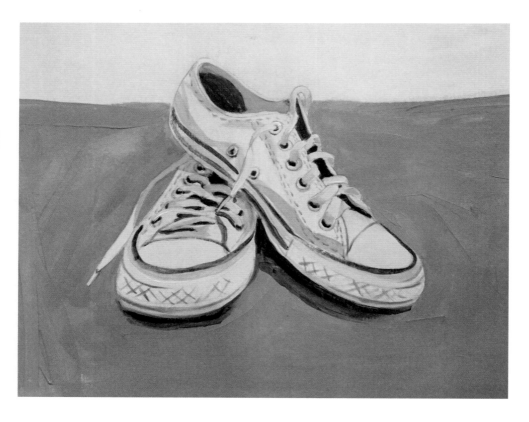

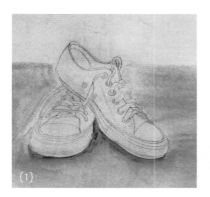 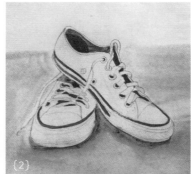 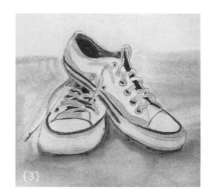

{1} {2} {3}

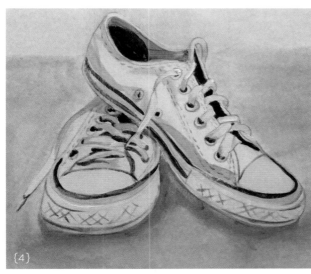

{4}

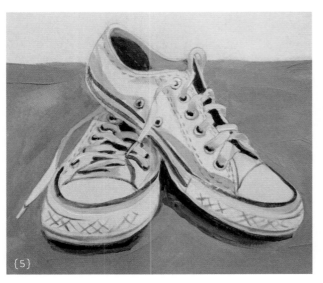

{5}

You will need: **Acrylic paper, a baker's brush, a filbert brush, a flathead brush and a pointed brush.**

{1} Lay down a wash of light green with a baker's brush and, when dry, lightly draw the sneakers in pencil. This wash will become the main colour of the sneaker. Add a little more green to the wash and paint a darker surface for the sneakers to sit on, with a darker shadow around the shoes, leaving the topmost part of the paper the original wash. {2} Mix cadmium red with a dot of green and use a small pointed brush to paint the dark areas of the shoes in this mixture, adding water when a lighter tone is needed. {3} Mix red and green together with a little white to make a lighter tone, diluting it to a watery consistency. Paint the shadows of the laces and the front and sides of the sneakers. Use a less diluted mixture for darker shadows such as the eyelets. {4} Now add the details – the cross-hatch texture to the front of the shoe and the stitching – with a darker version of the mixture used in step 3. Mix red and white to make a light pink to create highlights on the laces, the eyelets and the front of the sneaker. This will really bring your painting to life. {5} With a flathead brush and thicker green paint, paint over the surface the sneakers are sitting on. Use a filbert or pointed brush to carefully paint around the edge of the sneaker. With a pointed brush, add a shadow under the sneaker by mixing equal quantities of green and red paint.

LOCAL COLOUR – RED ONIONS

For this exercise I have used red onions, as they are an ideal subject for demonstrating how local colour (realistic colour, see page 22) can be achieved simply. The distinct purple required is adjusted by adding more red or blue until the exact colour match is attained. I used ultramarine blue and crimson red for the skin colour, with a little more red than blue.

A sgraffito technique (see page 58) was used to reveal the pink layers of the inside of the onion, and by utilizing the natural thick consistency of acrylics, the linear outer layers of the onions was emulated through texture alone.

* **TIP: When mixing your paint for the skin colour, it is important that a correct and consistent purple is achieved. Mix a fairly large quantity so that you don't have to make more.**

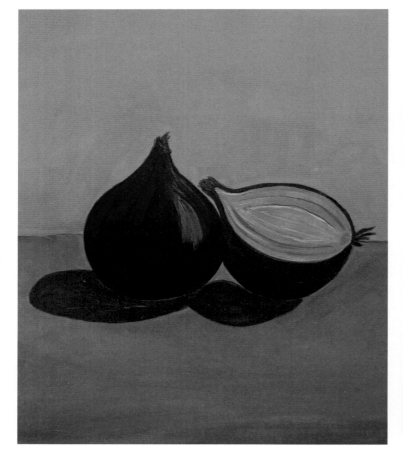

{1}

{2}

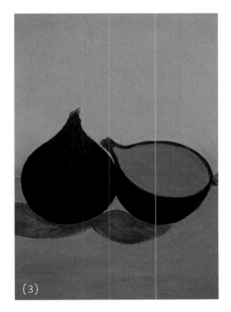

{3}

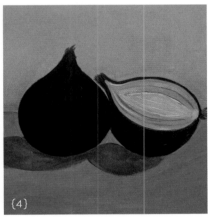

{4}

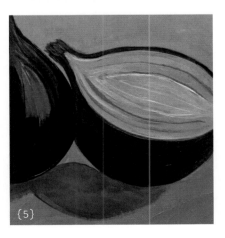

{5}

You will need: **Acrylic paper, board or primed canvas, a flathead brush, a filbert brush and a pointed brush, a pointed implement, cotton bud.**

{1} Use a diluted orange and blue to lightly paint a split background. Complementary colours make a striking background, which can be especially effective when the subject is quite minimal in terms of its own colour. When dry, lightly sketch the onions, then paint over the outlines with a pointed brush in a watered-down purple mixture. With more of the purple paint, fill in the onions with a filbert brush. Follow the direction of the skin when you paint, and paint just the dark outer skin for now. {2} Take some of your purple mixture and add a little white paint, dilute it slightly – you want a slightly thicker consistency than before, so not too much – and use this to cover the exposed inside of the onion. Paint over your background in another, less-diluted layer of blue and orange, so that it becomes more opaque and vibrant. (Working on both the foreground and background at the same time helps keep the painting moving all at the same pace.) Add a little of your purple mix to the blue and use this to paint the shadows from the onions with a pointed brush. {3} Using the purple mix, take a pointed brush and paint the skins of the onions more solidly, painting in the direction of the lines of the onion's layers. By combining directional brushstrokes with thick paint, you will see the paint start to resemble the ridges of the skin. {4} Make a white wash and paint over the inner part of the onion. Before it dries, use sgraffito to carve in the onion's layers with a toothpick or pointed tool and reveal the colour underneath. Using a pointed brush, carefully add some solid white to the central layers of the inside of the onion. {5} Add a little white to your purple mixture and dilute it. Sparingly, paint the highlights of the onion's skin using a filbert or a pointed brush, removing any excess paint with a cotton bud. Also, add highlights to the tips of the onions. {6} With a flathead brush, add a thin glaze of lemon yellow to the blue and orange background to add depth to the colours and balance to the overall composition. Gently remove excess glaze/wash with a damp cloth so that the yellow blends and does not look overpowering. Darken the shadows under the onions.

SYNTHETIC COLOUR – URBAN SKYLINE

This exercise uses solid, block colour, applied as both glaze and impasto, so it is a great introduction to combining different applications of colour, texture and layers. By simply replacing the natural colour of the sky, it also clearly demonstrates how synthetic colour (colour that is not the actual colour something is) can be really effective.

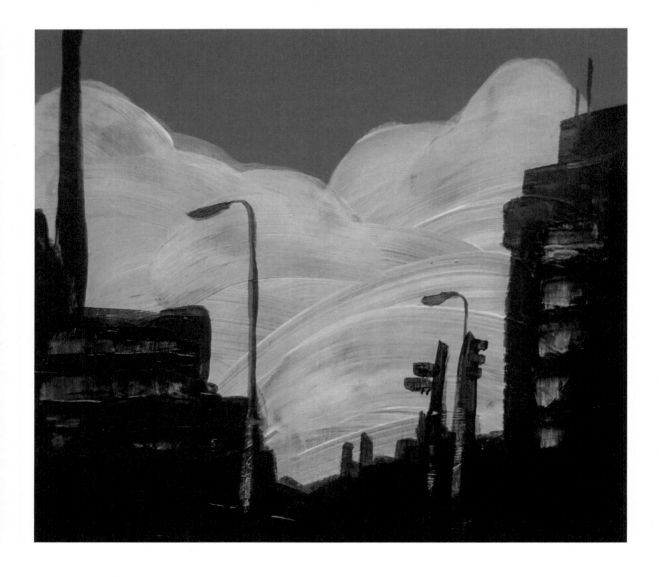

{2}

* TIP: Try using different
brush sizes for the clouds
to create different effects

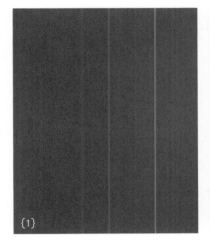

{1}

You will need: Acrylic paper, a flathead brush, a filbert brush and
a pointed brush, glazing gel (optional) and a pointed implement.

{1} Choose any colour other than sky blue for your sky. Paint the acrylic
paper in an even block of solid colour with a flathead brush. Keep the
paint flat by mixing it well and using very little water. I used crimson red
and a small dot of white to get a deep, crimson pink. Let this layer dry.
{2} Decide on the format of your painting – I chose a square format, and
marked it out on the paper. Mix some white paint with water or a glazing
gel. Apply this with loose, curving brushstrokes to emulate clouds, using
a filbert brush, allowing the background colour to show through. Allow
to dry. {3} Use a pointed brush to paint the skyline with a thick purple
paint, in an impasto style – this gives solidity, which contrasts with the
clouds. Use a pointed implement to scratch out the windows and any
lighter tones to let the lighter colours behind come through. This is
particularly effective in suggesting natural reflections.

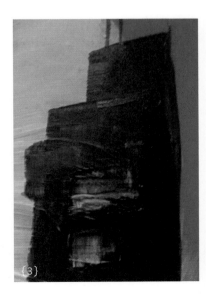

{3}

MONOCHROME – GLASS OF WATER

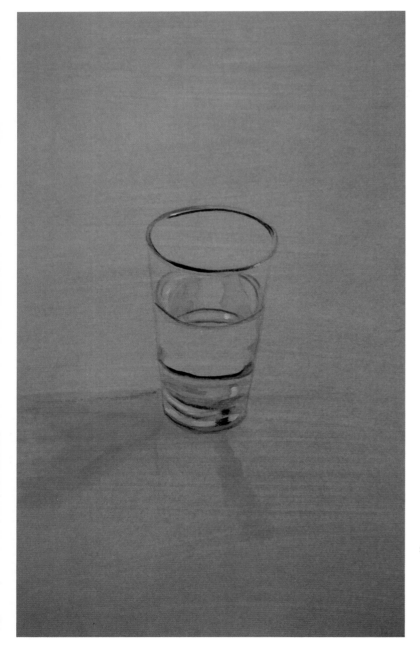

A glass of water is often considered a difficult subject to paint due to the transparency of the glass and the water, and the many reflections they catch. I want to show you here that it can be achieved in three easy steps using white paint and just one other colour. You can then apply the techniques you've learned to more complex colour schemes.

This exercise is all about tone – you don't have to think about colour mixing. You will simply be looking at the shapes created in the water, the glass and the reflections. Each shape has a tonal value.

We start by using a mid-tone for the ground, then adding the darkest tone, followed by a tone in between the darkest and the mid-tone, and then finally the highlights. Four tones – that's all there is to it.

＊ **TIP: Dilute the white you use for the water reflections, while using a thicker white for the glass. By mimicking the qualities of the things you are painting, you will create a more realistic impression of solidity, fluidity, etc.**

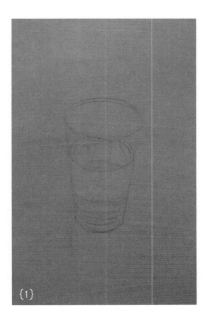

You will need: **Acrylic paper, a pencil, a baker's brush, a fine pointed brush and a medium pointed brush.**

{1} Choose any colour for your background – I have used purple made from crimson red, ultramarine and white. With a baker's brush, paint a wash over the entire paper – this will be your mid-tone. When the wash is dry, draw the glass of water, focusing on the basic tonal shapes you see. Half shutting your eyes can help you see these more clearly. {2} With a pointed brush, gently add the darkest tone, taking your time. I used the purple with no added white. Edges, such as the rim of the glass and where the top of the water meets the glass, will tend to have the darkest tones. Add a little of this purple to the mid-tone/background mixture, and water this down. Remove excess water from your pointed brush and work on the next darkest tone. Paint the sides of the glass with a very fine pointed brush. {3} Still using your mid-dark tone, paint the shadows of the glass. Now just add slightly diluted white for the highlights around the rim in the water reflections and on the glass.

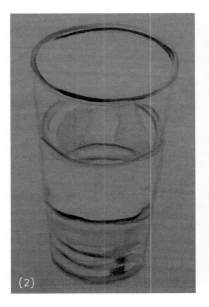

{1}

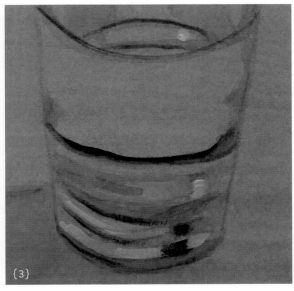

{2}
{3}

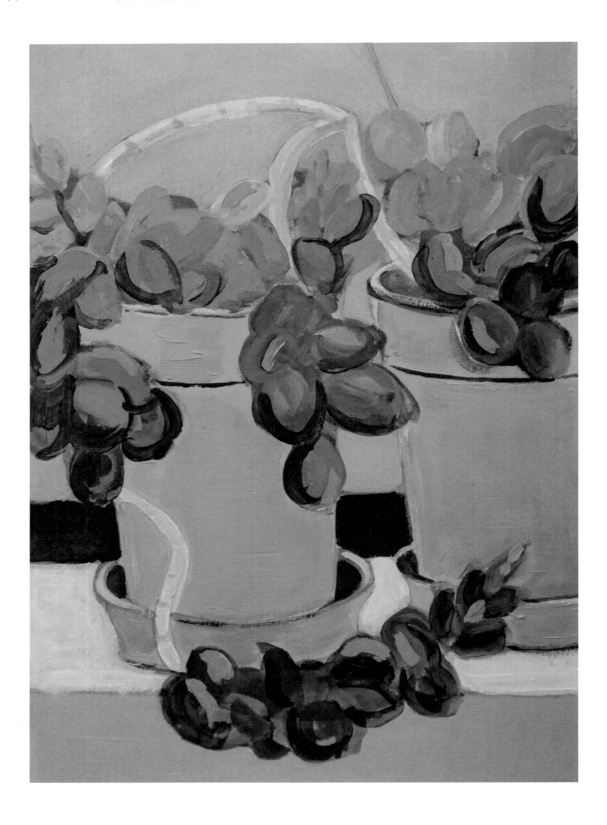

LIMITED PALETTE – STILL LIFE

Paint this still life loosely so that you don't get stuck in detail, and can instead just focus on the colour. To help you avoid the temptation of getting into details, use only larger brushes. The filbert brush is a good choice for this exercise. The first four stages are about laying colour down, while step 5 involves intensifying the colour and definition.

The palette I used was orange (cadmium red and lemon yellow), phthalo blue, green (phthalo blue and lemon yellow) and white.

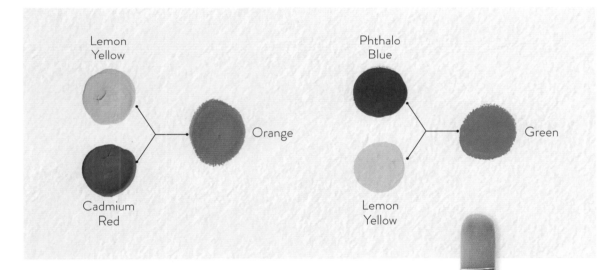

This exercise will look at the vibrancy that can be achieved using a limited palette – that is, three or four colours plus white. When these base colours are mixed together in different ratios, and by adding white, many various tones and shades will be produced.

You can arrange a still life to work from, or simply paint something already around you. I decided to paint what was directly in front of me on my studio windowsill: my plants. Some subjects might initially look boring, but colour can bring them to life. As we've already seen, complementary colours used together make each other stand out, and they generally tend to work well on a canvas together, so a pair of complementaries makes a great base for a limited-palette painting. Here, I suggest starting with a ground that is the complementary of whatever will be the main colour.

Filbert brush

You will need: Canvas or acrylic paper, a pencil, a baker's brush, a filbert brush, a flathead brush, a filbert brush and a damp cloth.

{1} Decide on your subject. Make a small sketch and decide which format will work best – landscape, portrait or square. Select a limited palette, make a bright ground colour, diluted with a little water, and paint this on using a baker's brush. {2} Lightly draw the outline of your still life. Paint the background around it with a filbert brush, using a colour that contrasts with the ground colour. I made a lightened phthalo blue, watered down so that the ground colour shows through. Paint different planes in a different tone; for example, I used a lighter blue for the windowsill. {3} Add a little of the ground colour to white and use this mixture to paint in any lighter areas such as the stalks of the plant here. Use a third colour to paint any other details. I made a green and loosely marked the leaves with a filbert brush. I also added white to some areas to create different shades of green. {4} Use the ground colour to add tone or definite edges of the lighter areas you painted in step 3 (the stalks, in my example). Mix a variety of tones of the third colour, in a thicker consistency, and apply this quite boldly. Use these shades to add a little more definition, but avoid any temptation to start working on detail – I added tone to the leaves. Mix some of your ground colour, keeping it undiluted, and add this to areas where the ground remains exposed. {5} Mix more of the background colour, again with no water, and add another layer of colour to the background. This second, opaque layer gives a deeper, more intense colour. Add this to some white for the lighter background areas marked out earlier, such as my windowsill. Mix the darkest tone you can achieve with your palette and apply this to any shadowed areas. I mixed phthalo blue and a little orange together to achieve this. If there are any simple details you wish to add – such as the fine lines of shadow on my pots – you can apply these now with a smaller brush.

{1}

{2}

* TIP: Leave areas of the ground colour showing through where there are edges – this will add more brightness and interest to your painting.

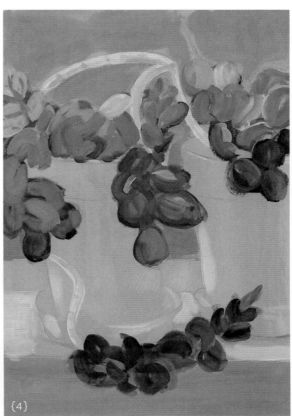

{4}

{3}

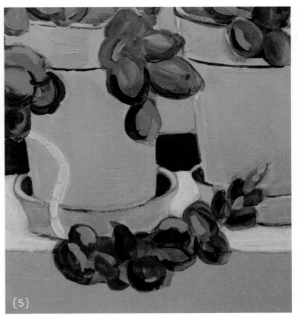

{5}

MULTICOLOUR – BIRDS

This exercise demonstrates how to create a striking image by subtracting the background. My painting is of three birds, but you could use figures, geometric patterns, architecture – anything.

 The abstract image you start from could be anything you can paint on top of, but my suggestion is to use a painting from the earlier paint pouring exercise (page 48), since this should feature the interesting shapes and bright colours you need. I did not want to paint over the actual artwork, so I made a good quality photocopy of it.

 As the acrylic paint will be painted on using little or no water, it will dry very glossy. I personally think this exercise looks better when matt, so I put a matting agent on top of the finished work.

{1}

{2}

* **TIP:** If you want to paint over an actual painting, add a soft gel medium to your acrylic paint. Dry acrylic paint is very smooth and can be difficult to paint over, so the medium this will help subsequent layers of paint stick to the surface.

You will need: **A colourful abstract image – use the paint pouring technique (page 48) or make a photocopy from one you made earlier – a paint pen or marker pen, a flathead brush, a pointed brush and (optional) a matt glazing medium or a matt varnish spray.**

{1} **Choose a multicoloured abstract image to start from. If you're using a photocopy, or you want to add your own touch to a ready-made design, you can add more colour with some acrylic paint or acrylic paint pens.** {2} **Use a paint pen or a marker pen to draw the outline of your design; here, I have drawn birds.** {3} **Use a dark colour – I used pure black – to paint around the design. Use brushes appropriate for the size you're working to – a pointed brush for any details, and a flathead brush to lay down large areas of colour. To make the colour solid and opaque as it needs to be, paint two layers, allowing the paint to dry thoroughly in between. When dry, either spray with a matt varnish or use a matt glaze medium to paint over the surface in a thin layer.**

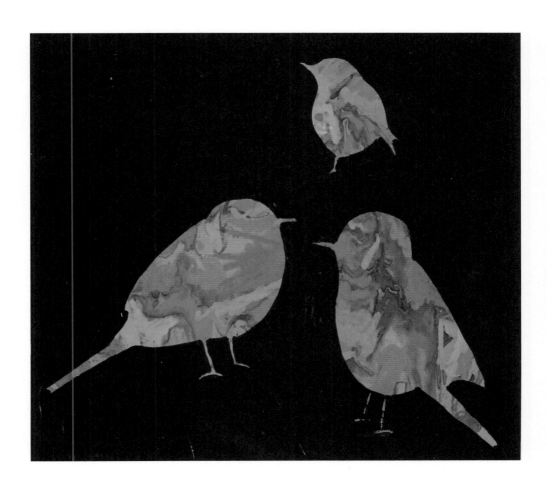

LINE

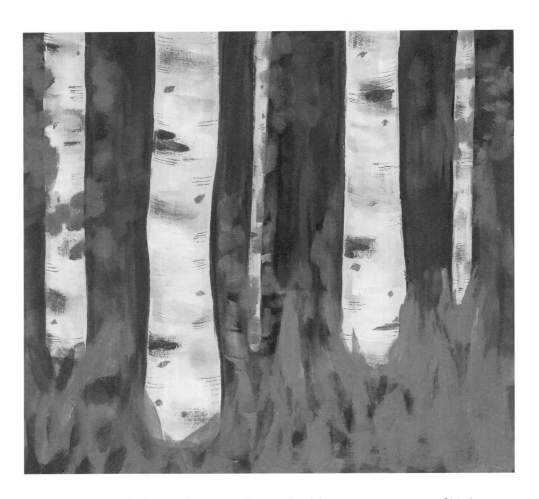

MARKS – BIRCH TREES

As I was walking around a woodland, I came across a group of birch trees. It occurred to me that the trees would make a great subject to paint when thinking about line both in terms of composition and mark-making.

The trees are themselves vertical lines, which are then complemented by the lines of the contours and marks on the trunks. The roundness of the trunks can be defined by using directional brushstrokes and scratching marks onto the painted trees using small scissors.

This exercise also uses a dry brush mark technique. As the name suggests, this technique involves using a brush that is dry/almost dry, putting on a little bit of paint and removing excess, so that when the brush mark is made it looks scratchy and lets the paint colour underneath show through parts of it. It has a rough appearance.

You will need: **Acrylic paper, canvas or board, a baker's brush, flathead brushes in different sizes, a filbert brush, a small pair of scissors and an acrylic retarder medium.**

{1} Sketch some tree trunks in various positions. Paint a coloured ground, and when dry, use a darker complementary colour to paint the background behind the trees. {2} Mix green paint and add just a little water. With a filbert brush, loosely paint some of the foliage. Make a lighter version of the background colour by adding white; this is for the tree trunks. Mix this colour with a retarder medium to slow the paint's drying, then using a filbert or flathead brush, paint the trees. Before the paint dries, use a small pair of scissors to scrape away some of this paint to reveal the ground colour behind. This suggests the tree's markings (the spots) and form (the curved, linear contour marks). {3} Using dry brush marks, add some white paint to the trunks. {4} Mix varying tones and shades of green and add to the foliage in a loose manner. Use a small flathead brush to paint directional dry brush marks using a mid-tone colour. Mix a dark colour similar to the background colour and, sparingly, add this to the darkest areas on the trees.

* TIP: The tree bark will be in detail while the background is painted loosely. This will help the mark-making and lines on the tree stand out in contrast.

{1}

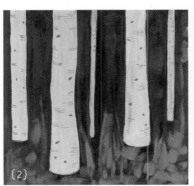
{2}

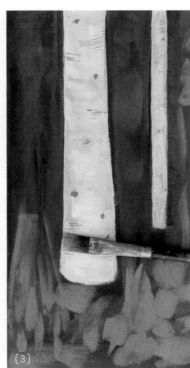
{3}

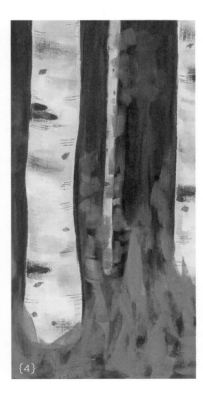
{4}

FORM & LINE – PAINTBRUSH POTS

If you need to loosen up your
painting and become more
confident with your mark-making,
then this exercise is for you. It
encourages you to make a mark
or paint a line without trying
to make it perfect – it will be
corrected by another line added
later. With acrylics, you can cover
previous marks with a darker or
more opaque line. I have used a
large sheet of paper (A2), which
encourages a looser mark and a
freer style of painting.

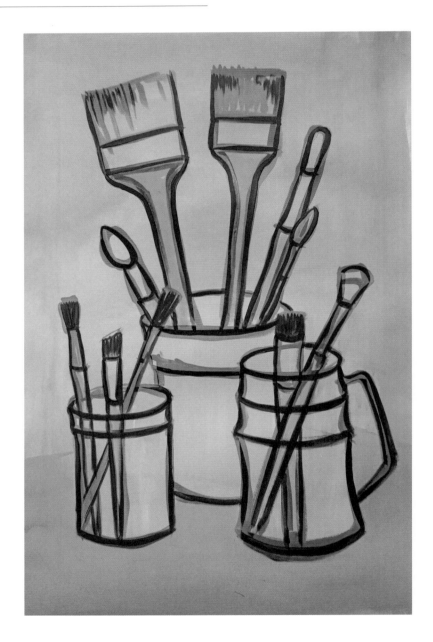

{1}

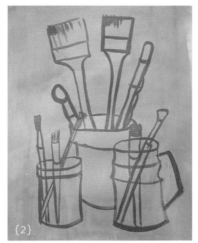

{2}

* TIP: Don't mix too much paint. As it is a line painting, it will take very little paint to cover a large area.

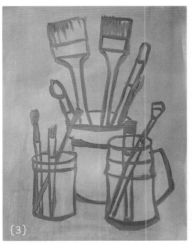

{3}

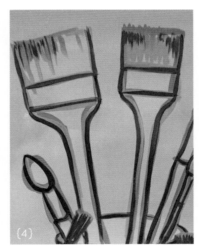

{4}

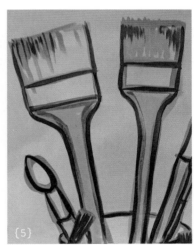

{5}

You will need: Acrylic paper, a baker's brush and a filbert brush.

{1} Use a baker's brush to cover the paper in a light turquoise colour. I used phthalo blue, lemon yellow and white to make this. Use buff titanium mixed with white to paint over the top half of the paper with a baker's brush, allowing the turquoise to show through. This can be achieved by using dry brush marks (see page 80) or by diluting your paint well. Make a more opaque mixture of buff titanium and white, adding less water, and with a baker's brush roughly paint the shape of the largest pot. {2} With a small filbert brush, use a fluid pink mixture (cadmium red and white) to paint the outline of the pots and the brushes. As you work, do not try to correct any lines you make. Allow this to dry. {3} Repeat step 2, now using an orange mixture, to once more paint the pots and brushes. Aim to correct and improve your previous marks. {4} Repeat again with phthalo blue. {5} Water down the phthalo blue and use a baker's brush to paint the surface the pots are standing on. Then, using the filbert brush, paint the body of some of the brushes.

TONE & LINE – CRINKLED FOIL

This tutorial will help work with line to practise seeing and recreating shapes and edges. You will take a piece of aluminium or tin foil and loosely crinkle it, then transfer the shapes you see into a line drawing, which you will then fill in with paint based on the tones you observe. You will be using just three tones: a light tone, a mid-tone and dark tone. The foil will have three or more tones, but try to simplify them to three.

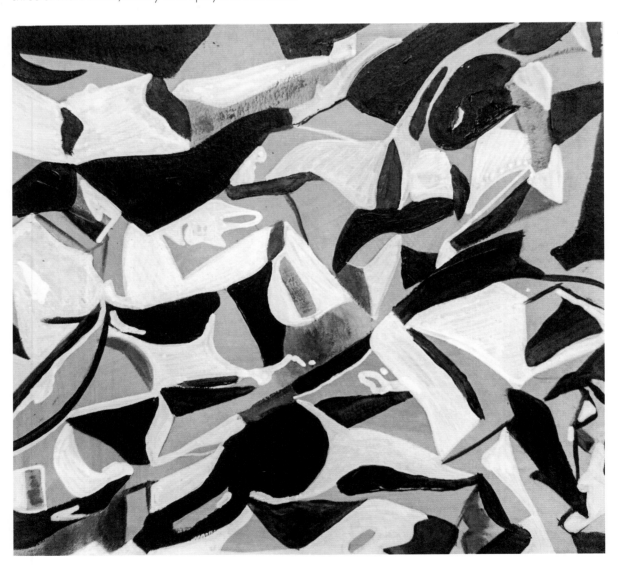

This exercise requires a lot of patience and perseverance, as it is not until you are filling in the last few shapes that the piece suddenly comes together. Observational work like this can be daunting and painstaking, so it can help to work on a small scale.

The finished painting looks great as an abstract piece. I suggest using three related tones: one dark, one mid-tone, and white (I used purple and lilac plus white), but you can play around with using different colours.

{2}

{1}

{3}

You will need: **Aluminium or tin foil, acrylic paper, a pencil, a baker's brush or flathead brush, a small pointed brush and a small angular brush.**

{1} **Look at a section of crinkled foil. Using a pencil, transfer the shapes you see by following the lines until you have filled the square of paper.** {2} **With your mid-tone colour, make a wash and paint this across the surface of the paper. As the paint is watery, there will be slight differences in tone; this works well in the finished image. Leave to dry.** {3} **Mix the darkest tone with very little water so it has a thick consistency and a stronger, more solid colour. Paint in all the darkest shapes.** {4} **Mix the lightest paint colour with very little water again so it has a thick consistency, which it needs to cover the mid-tone. Paint in all the lightest areas. The mid-tone may show through a little, which gives it a natural, painterly look. I used white.**

∗ **TIP: To make the lightest colour more opaque, two layers may be required. Allow the paint to dry in between layers.**

CONTOURS – HILLS & VALLEYS

In this painting, the contour lines of fields on a hill help direct the viewer's eye around the image, and also create a feeling of movement in a still landscape. The lines are revealed using the sgraffito technique, and the edges are then softened by partially painting over some of them. A canvas or board is the best support for doing sgraffito, but paper will suffice if these are not available to you – just be careful not to scrape too hard and tear the paper.

　　I used a flathead brush to paint the ground colours, creating a precise line between the two. I also used flathead brushes to paint in the fields and the shrubs in the foreground. The filbert and pointed brushes were used for the distant trees and shrubs, and the shadows along the sgraffito lines.

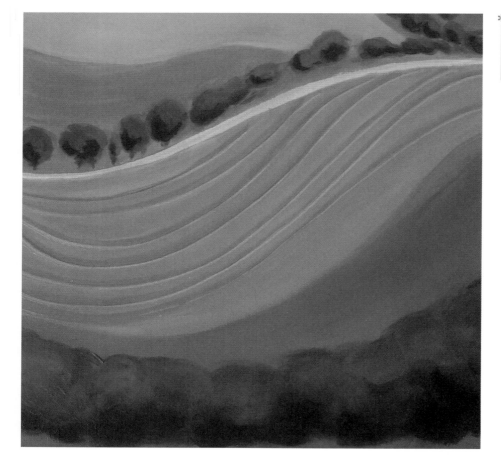

✳ **TIP: When doing sgraffito, if you make a wrong mark, just paint back over it and do it again.**

{1}

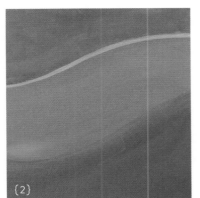

{2}

You will need: **Canvas, paper or board, a pointed implement, medium and small flathead brushes, a medium filbert brush and a small pointed brush.**

{1} Find an image of a landscape where there are plough lines or fences as well as dividing boundaries between the fields. Paint the ground using two contrasting colours, dividing up the fields and therefore creating a line. Allow to dry. {2} Mix a green using very little water, as this will need to cover the ground colour. Paint the fields, varying the shade of green for different fields or areas. Leave a narrow space exposed where the two ground colours meet, to form a line between the fields. {3} Before the paint dries, use your pointed implement to scratch away any lines that you can see in the fields. If you cannot see any lines, then use sgraffito to create the contour of a rolling field. Use a mid-green to soften and paint back over some of the sgraffito lines so they are softer and more subtle. {4} Mix a dark shade of green using plenty of blue. Using a filbert or a pointed round brush, loosely paint the trees and shrubs you can see along the borders of the fields. {5} Add water to your darkest shade of green, and with a pointed brush, paint a shadow line beside the sgraffito marks to make these lines appear more undulating and add a realistic depth. Make a deep purple using red and blue, and use this to add more definition to the trees and shrubs – the purple recalls the lilac used in the ground colour.

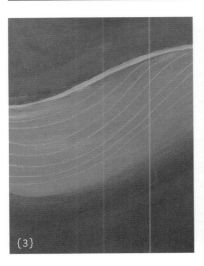

{3}

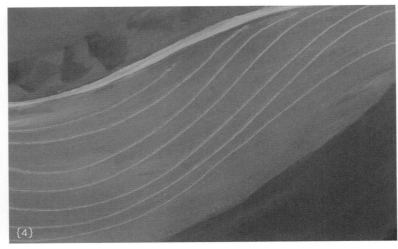

{4}

OBSERVATION

The aim of this tutorial is to show you how painting small and quick sketches can help you when putting together a composition. When making your sketches you will soon get a sense of whether the image will work as a full-size painting. It is better to find out now rather than halfway into a large canvas! It's also an excellent opportunity to experiment with colour, and making small sketches first will build your confidence to attempt a larger project.

I sometimes do ten of these on a sheet of paper. They are nice little paintings in their own right and look good as a set. Remember, these are not detailed paintings: they are paint 'sketches' – just quick ideas. Even the boxes you draw to paint inside don't need to be neat, just rough squares.

For this exercise, first you need to take a walk around your city, taking photographs and making pencil sketches. Cityscapes are not just skylines but recognizable buildings and areas. You could use iconic imagery or the landmarks you are familiar with in your own environment. This exercise can be applied to landscape, still-life – anything – and the sketches are fun to do.

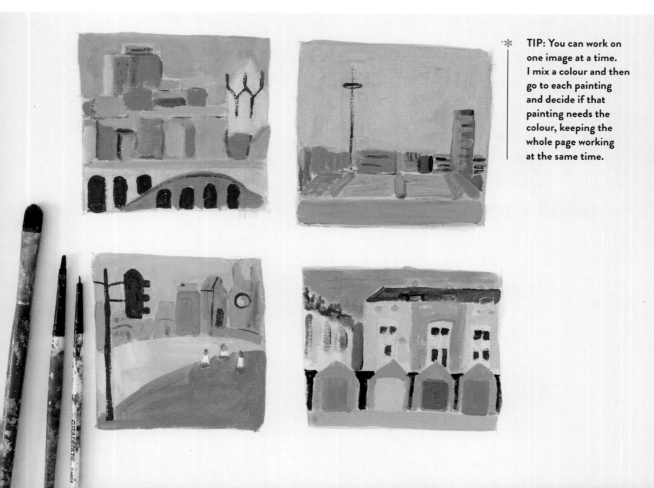

* **TIP: You can work on one image at a time. I mix a colour and then go to each painting and decide if that painting needs the colour, keeping the whole page working at the same time.**

QUICK STUDIES – CITYSCAPE

{1}

{2}

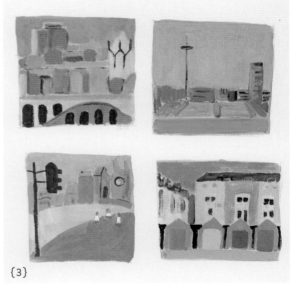

{3}

You will need: Acrylic paper, a pencil, fine brushes such as small flatheads, filberts and pointed brushes.

{1} In pencil, mark out roughly some squares and rectangles. I made four, each about 8–10cm (3–4in) in length. Choose a photograph or sketch and draw the outlines of what you see. Consider as you work whether or not the composition is working. {2} For each sketch, start with a wash in a new colour, and paint this as a ground. This is a chance to experiment with different ground colours, to see what effect different colours have on the look of the finished piece. {3} Mix a wide variety of colours in small quantities on your palette, so that you have a wide selection to choose from. As you paint into the outlines of your sketches, be creative and try out colours in places that you might not normally see or use them – this is a chance see what works. You might find that painting in a pink sky gives an interesting look to a piece, or that certain colours work well together when you wouldn't have expected them to.

Paint at least four sketches, and when you have finished, look at your page. You will quickly see which ones are most pleasing to your eye, and you can make a note of those you struggled with or are not working. Think about why a piece works or doesn't: does the composition look balanced? Are the colours too muddy, or clashing? Use the sketches that work to make a more detailed painting.

GROUND CHOICE – DISTANT FIELDS

Your ground colour is the colour that the rest of your painting is built on. The colour you choose can add vibrancy, coolness, darkness, brightness and other qualities to your painting. This exercise demonstrates this by using two different ground colours for the same image. I used lilac and orange for my grounds, and then painted the exact same landscape on each one. I used two different sky colours – phthalo blue for the lilac one and ultramarine for the orange one, but the rest of the two paintings were painted with the same colours.

Try doing as I did and sketch your landscape from life. When doing this, remember to draw what you see, no matter how odd it looks; it will all eventually knit together like a jigsaw puzzle. If you don't have access to a landscape like this, remember that you can use any subject to try this, and you can always try copying a photograph instead.

✳ TIP: Make sure there are both very light areas and very dark areas. This adds to the dramatic view and gives a sense of depth. You can adjust the shades of green by altering how much blue and yellow are used for mixing: the more blue a green has in it, the darker it becomes.

{1}

✳ TIP: Keep the painting loose and quick by avoiding small brushes.

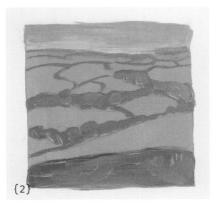

{2}

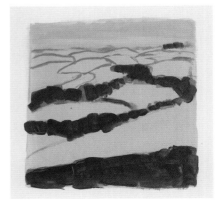

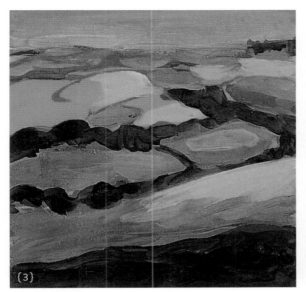

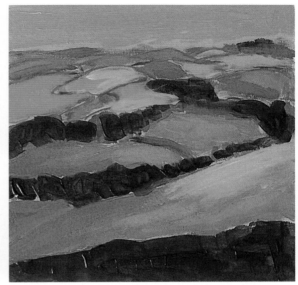

Orange base Lilac base

When you have finished, look at your paintings for a while. The differences will be subtle, so it's worth spending a while to do this. Consider the following questions: Does one feel warmer than the other? Which one did you enjoy painting more? Did the colours you applied act differently on each coloured ground?

The choice of ground colour is both a matter of taste and a factor in determining the overall effect of a painting. It's good to see for yourself what you like and what effects your choice might produce.

You will need: **Acrylic paper, a pencil, a flathead or baker's brush, a filbert and a large pointed brush.**

{1} **Draw two squares. Choose two contrasting colours and use each to paint a ground colour, with a flathead or baker's brush. When dry, use pencil to sketch the outline of the fields, marking different shapes from the boundaries you see.** {2} **Use the darkest colour you have to paint the trees, shrubs and foliage that divide the fields; these are generally the darkest objects in a distant view like this. Paint loose, waving and circular marks with a filbert brush. Do this in both squares at the same time. Paint the sky. Here, the grounds suggested a different sky colour for each, so I decided to experiment and used two different shades of blue.** {3} **Mix the colours you see in the fields. I used green from phthalo blue and cadmium yellow, and orange made from cadmium red and cadmium yellow. Use the large pointed brush and the filbert to paint these areas. Suggest some tonal variation by adding white or a lighter colour. I added white and yellow to the green, and white to the orange. Leave little gaps between the different colour areas to allow the ground colour to show through. You will notice that the painting on the orange ground is a little more vibrant and bright, while the painting on the lilac ground has a little cooler cast. The lilac works well with the green of the landscape and is more subtle than the orange.**

LANDSCAPE – INTO THE WOODS

A walk through a woodland is a great opportunity to gather images for paintings. There are intense colours due to the rich contrasts produced by the light filtering through the treetops, and you can translate these into bold, synthetic colours. I chose to paint some woods near where I grew up; I have fond memories of being there, therefore I used bright colours to reflect this. Even a small copse will do, but if you don't have access to a woody area, work from a photograph that evokes similar memories or emotions.

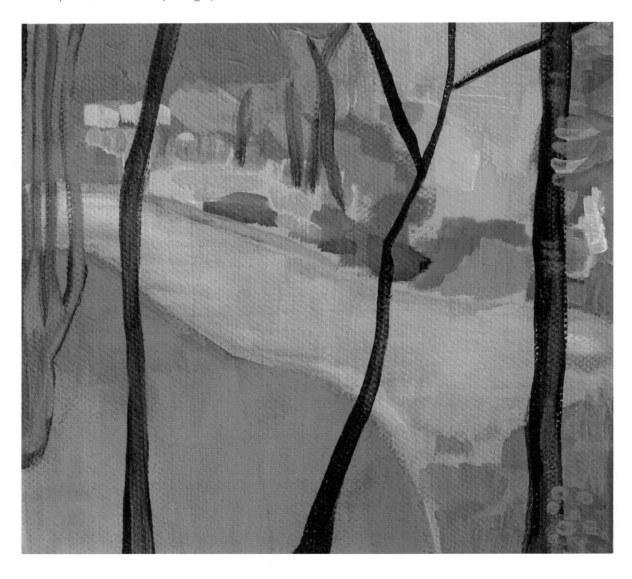

Making a drawing of a place helps you to observe it more closely while you are there, enabling you to see shapes and colours you would not normally notice. As you take a walk in the woods, stop to make some drawings, take photographs and gather objects, such as leaves, to take home and remind you of the colours and feelings of being among the trees. Pay close attention to the shapes created by branches, and any flora and fauna you spot. Notice the colours. I chose to intensify colours that I saw; for example, I noticed a little red toadstool, and that red became a much a larger area in my panting. Work up to a composition ready for painting. You can make several little paint sketches first, as with the cityscape sketches on page 88.

When it comes to your colour choices, be adventurous. Use colours that you see but also synthetic colours (see page 22) that work well with the composition. I observed the woodland and abstracted information from it – selecting certain shapes, lines, colours, and so on. I also omitted some information: you don't have to paint everything you see. I used my observations to create a composition that straddles reality and abstraction.

You will need: **Acrylic paper, canvas or board, a pencil, a flathead brush, a filbert brush and some small brushes (such as a small filbert brushes and pointed brushes).**

{1} **Choose a light, bright ground colour to make a ground. I mixed a very light orange to create warmth and light. Dilute with just a little water – the paint should be thicker than a wash – and paint the ground with a flathead brush. When dry, draw the basic lines of your composition in pencil.** {2} **For this exercise, we are working from the back of the scene to the front, so start by painting the background areas that you have observed behind and under the trees by blocking in areas of colour. Paint these quite loosely using a filbert brush. I used greens, pinks, reds and turquoise.** {3} **Start to add other colours and details such as leaves, grasses and other foliage – all but the trees. Use loose brush marks that suggest foliage; a small filbert is good for this as it has a rounded edge like the leaves. Overlay some colours as glazes (see page 52). Use all your brushes to create different brush marks.** {4} **Mix a dark colour on your palette; I used purple. Use this to paint the trees using the small filbert and pointed brushes. Use the filbert for the body of the trunks and the bigger trees, and the pointed brush for edges, branches and detail. You can add detail to the trees by adding another colour to the tree trunk such as the slightly lighter blue I used. Finally, add any plants that are in front of the trees.**

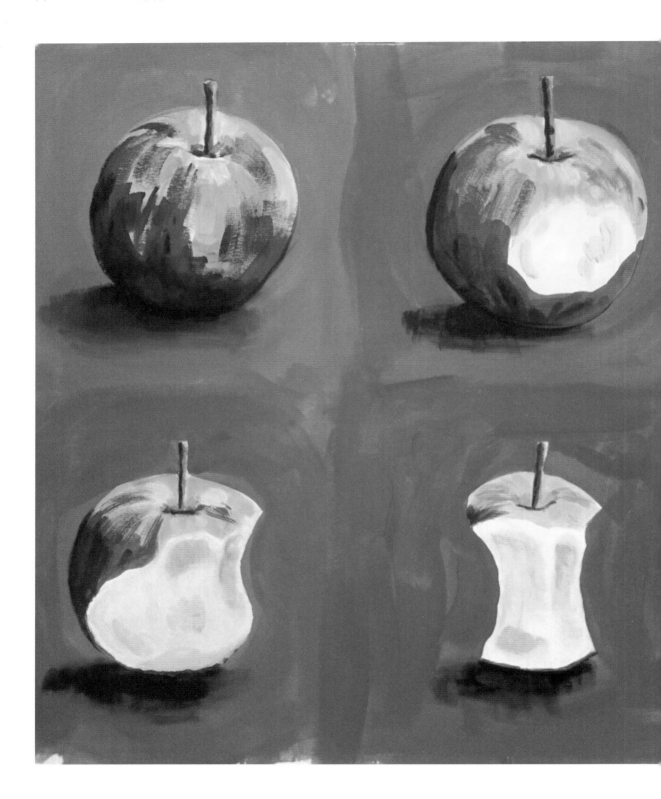

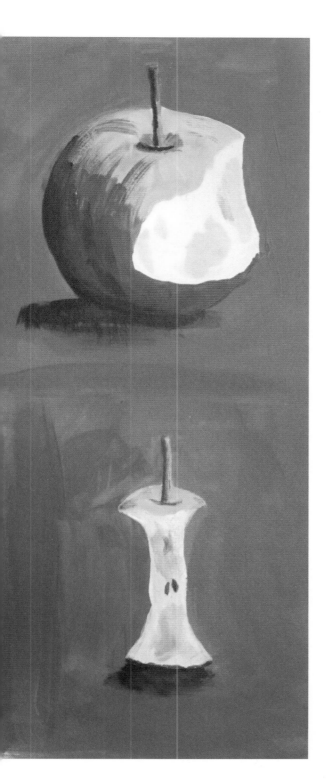

STORYBOARD – SIX APPLES

This exercise shows you how to paint what you see and not what you think you see. Using greens, yellows and reds in a variety of shades, and through building form with several thick layers of paint, you can emulate the character, shape and colours of an apple in five bites.

Look closely at your apple and create a palette with all the colours and shades that you see.

Before you begin, make a ground colour by mixing together phthalo blue, titanium white and cadmium yellow, diluted with a small amount of water. The results should be a pale green colour with the consistency of a wash.

* **TIP: I have anchored my apple with a shadow, to prevent it from 'floating'. I mixed the red of the apple and the blue of the background to create a deep purple shadow, which I used to suggest the surface the apple is sitting on.**

※ TIP: I've chosen a blue background to give contrast to the apple.

{1}

{2} {3}

{4a} {4b}

You will need: Acrylic paper, a pencil, a baker's brush, a flathead brush, a filbert brush and a small pointed brush.

{1} Divide a large sheet of paper into six sections and apply the ground colour using a baker's brush across the whole sheet. Once dry, draw the basic shape of your apple in the first square. Using a flathead brush, fill in the background around this shape in blue. {2} Using a pencil, lightly divide the apple into areas of light and shadow. Start painting from the top of the apple down, using contoured brush marks to emulate its form, and varying your colours to match those of the apple. Mix the red of the apple and the blue background to make purple, and use this to paint the shadow and the darkest tones. {3} Add the highlights last and use dry brush marks to create flecks. You can also now add some little details with a pointed brush. {4} Take a bite from your apple and repeat steps 2 and 3, allowing some of the ground colour to show through where the bite was taken. Repeat this process until you have six paintings, taking your apple from a whole to a core. {5} The inside of the apple will begin to brown, which can be shown by adding some buff titanium paint and rubbing it in with your finger.

STILL LIFE – KITCHEN TABLE

This exercise is designed to help you look at shapes, negative space (space around objects), tone, contours and composition – so there is quite a lot to take in!

To inspire your own still life, it's helpful to look at another artist's work, whose still life paintings you admire. You can even see this exercise as an homage to them; that is, by emulating the style of that person in your painting. I looked to the wonderful Mary Fedden.

When working with vibrant colours, it can be best to keep primary colours to a minimum and use mostly secondary colours, as this will be more aesthetically pleasing (lots of primaries together can look garish). I used crimson red, purple, orange and a deep green/blue. I also used buff titanium and titanium white for the lighter areas.

To create your still life composition, choose two or three objects of varying heights. Try observing the arrangement through a camera as well as with your eyes – this can help you frame the image and choose a composition that works well. As you look at your composition, consider: Does it look balanced to you? Are there any areas that are boring or too busy? A pattern can help add definition to an object's shape. I used eggs in a shallow bowl and a vase, as they created pleasing curves and echoed the round table.

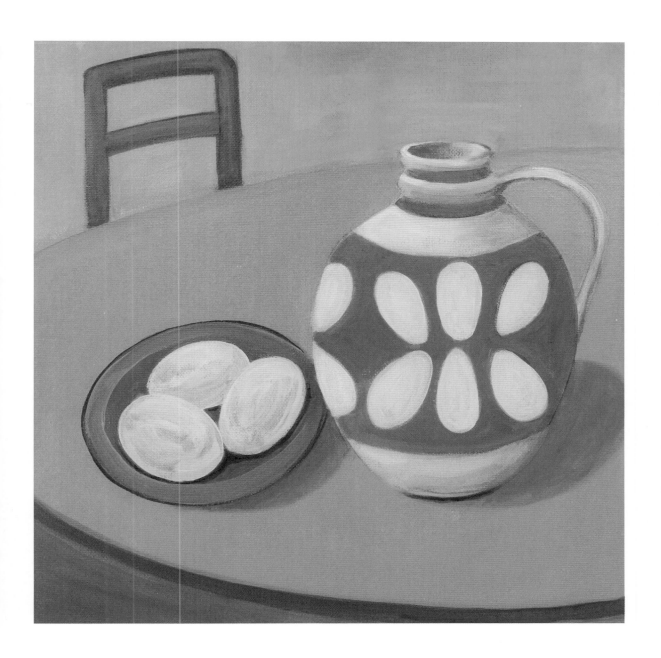

You will need: **Acrylic paper or canvas, a pencil, a flathead brush or a baker's brush, a larger pointed brush and a small pointed brush.**

{1} For your ground, create washes of two colours that are close to one another on the colour wheel, and apply these one at a time to your surface using a flathead brush or baker's brush, leaving each to dry before applying the other. By using two colour washes, the ground colour will appear more vibrant and deeper. When dry, sketch out your composition in pencil. Choose one of the wash colours to become the surface your objects are resting on. Mix this with just a little water so that it's a thicker consistency than the wash, and use a flathead brush to apply. Keep to this consistency for the rest of the painting. {2} Mix another secondary colour. Create up to three tones of this colour by adding white. I made purple and two lighter shades of lilac. Paint the background and objects using the most appropriate of the three tones you have mixed for each part. You can use a damp cloth to remove areas of paint applied at this stage and reveal the ground colour. {3} Use your primary colour to paint any darker areas – in my painting, these were the underside of the table and the chair. Use the darkest of your secondary colours to mark any shadows and edges, as I have done in purple around the edge of the table and for the egg bowl. Add buff titanium or a cream colour to lighter areas and highlights. Use this only on the objects, rather the background elements, as this makes your subjects stand out. Following the style of Mary Fedden, I also wanted to maintain the flatness of the surface and the background. Buff titanium is quite transparent, so it does allow colours beneath it to subtly show through, as you can see where I used it on the eggs.

{1}

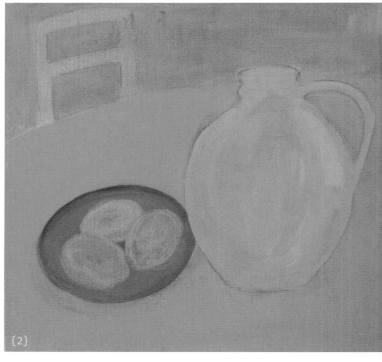

{2}

✳ **TIP: If you are unsure of the tones, you can take a photo of your still life and make it a greyscale image in a photo editor – this will clearly show you which objects are darker and lighter.**

{4} Mix another secondary colour – I made a deep blue-green –and use this to paint any darker areas. I used it for the pattern of the vase, and also painted over the primary red of the chair to make an even darker tone. Add light tones by adding the secondary colours to white. Use white to add highlights on edges. {5} Add definition with the darkest of the secondary colours. I used purple and defined the eggs with a very small pointed brush. {6} Use the primary colour to paint the shadows under the objects.

{3}

{4}

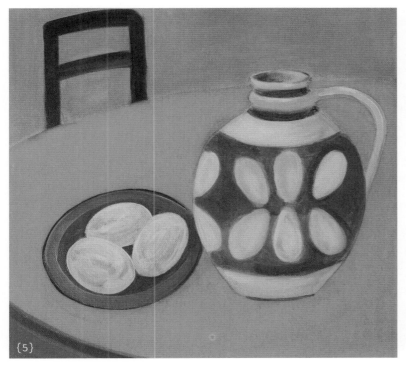

{5}

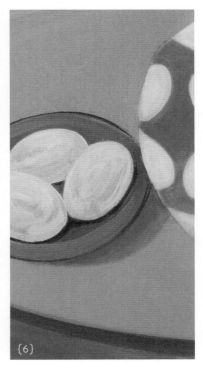

{6}

MIXED MEDIA

Collage is good fun, but finding suitable images to repurpose can sometimes be difficult. For this exercise, you will be painting paper that will be torn up to make a collage image. Newsprint is best for this, as it is easy to tear and stick, but cartridge paper can be used too.

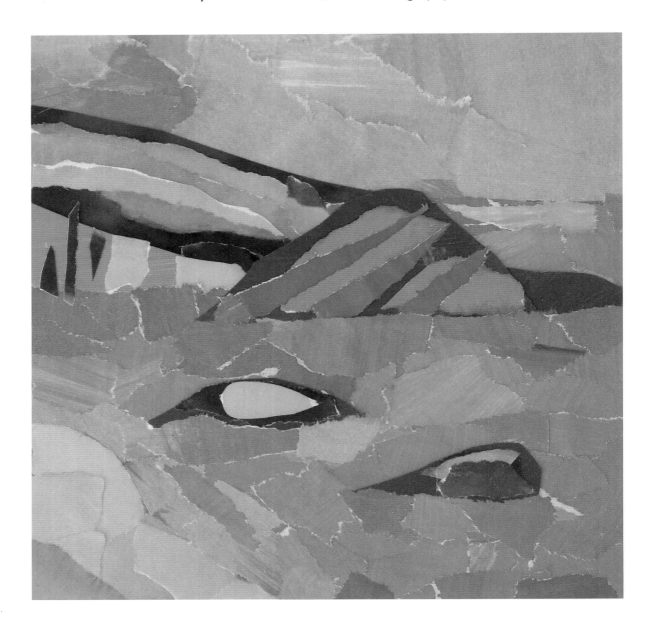

COLLAGE WITH PAINTED PAPER

There are a couple of ways of doing this: you can make a drawing and then work it up using collage, or start with a collage and use paint and graphite on top to add detail. This example uses the first method, but you can really do it any way you like.

{1}

{2}

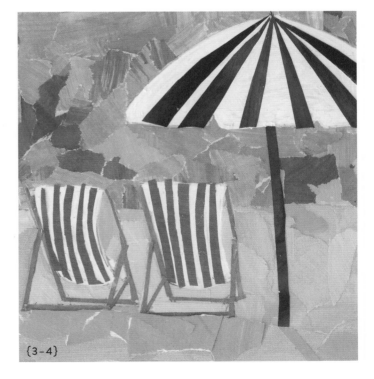

{3-4}

* **TIP: You can use scissors to cut specific shapes as I did with the deckchair stripes.**

You will need: **Newsprint or cartridge paper, a glue stick and a pencil.**

{1} Paint different colours and tones onto sheets of newsprint or cartridge paper. You won't need much; consider the size of the collage you are making. {2} Draw a simple image onto a sheet of paper. The deckchairs I chose quickly became very fiddly and awkward. I also used a ground colour, but this is optional – it just means that any small gaps won't be glaringly obvious. {3} Start tearing up the painted paper for your background. Keep the pieces fairly small. Use different shades of colour, rather than making an area all one colour. Glue into place. {4} Continue to work into your collage, adding detail. If you like, you can finish by adding extra details in paint or other media.

PHOTO PAINTING

Acrylic paints are great for painting over photographs, as varying consistencies can be used to create different effects. Acrylic paint adheres well to photographs, especially when they are printed on matt or a semi-gloss paper.

⇶→ PAINTING OVER PHOTOGRAPHS

- Paint out areas you want to obscure.

- Paint over an image exactly as it appears. This is a great way to practise painting. You can do this on any subject – I have demonstrated this by painting over flowers.

- Add to the painting by adding in objects or masks as I have done with the portrait opposite.

- Tint a black-and-white image with colour.

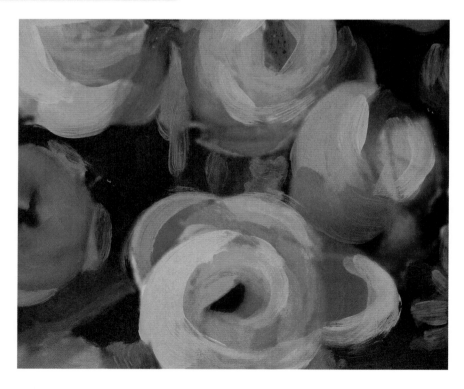

You will need: **Photographs or photocopies and a selection of brushes.**

{1} Find photographs you don't mind painting over – you can often find old photographs and postcards in second-hand stores – or make a photocopy. {2} Decide which of the techniques opposite you want to try. {3} Use paint straight from the tube. You may prefer working with a soft-bodied acrylic or adding a soft gel to a heavy-bodied acrylic paint, as this gives it more adhesion. Do not dilute the paint with water as it will just pool on the photographic surface. {4} Vary your technique. Choose different approaches from the suggestions opposite, or come up with your own ideas. Think about how you want to use colour, especially if you're working over a black-and-white image. Use this to practise different acrylic techniques we've already looked at, in a purely experimental way. You don't have to worry about the outcome in this exercise – just have fun!

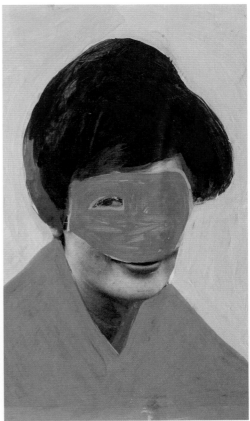

* TIP: Sgraffito can also
be used on a photograph
using a sharp tool.

PAINT PEELINGS

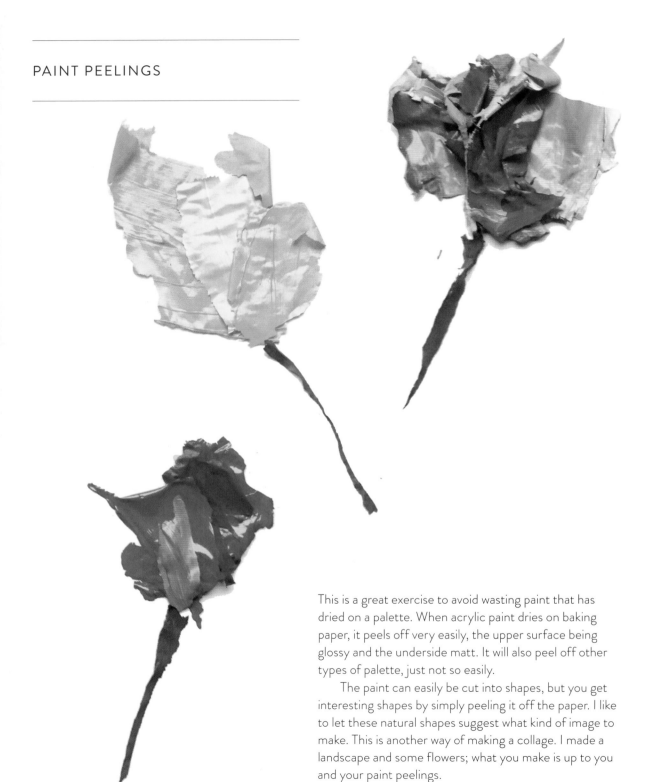

This is a great exercise to avoid wasting paint that has dried on a palette. When acrylic paint dries on baking paper, it peels off very easily, the upper surface being glossy and the underside matt. It will also peel off other types of palette, just not so easily.

The paint can easily be cut into shapes, but you get interesting shapes by simply peeling it off the paper. I like to let these natural shapes suggest what kind of image to make. This is another way of making a collage. I made a landscape and some flowers; what you make is up to you and your paint peelings.

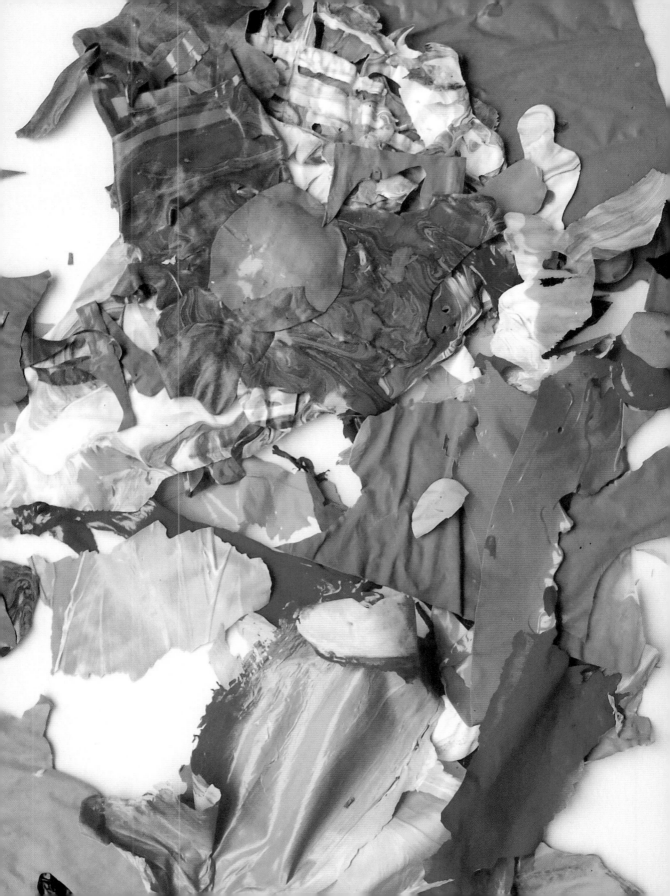

✳ **TIP:** You can paint baking paper solely for the purpose of making paint peelings.

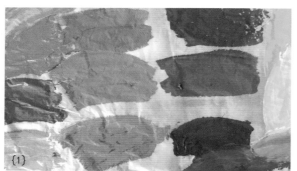

{1}

{2}

{3}

You will need: Paint peelings/baking or greaseproof paper, gel medium (used as an adhesive), paper and (optionally) a flathead brush for painting a ground.

{1} Paint shapes of different colours onto baking paper (optional). {2} Peel the dried paint away from your baking paper or your dedicated palette and examine all the shapes and colours you have. {3} Paint a ground colour onto a piece of paper or you can work on top of another image, or just on a plain white surface. {4} Start placing the paint peelings, a little like a jigsaw, and begin creating an image. {5} When you've decided on a composition, glue the shapes in place with a soft acrylic gel or glue stick.

{4}

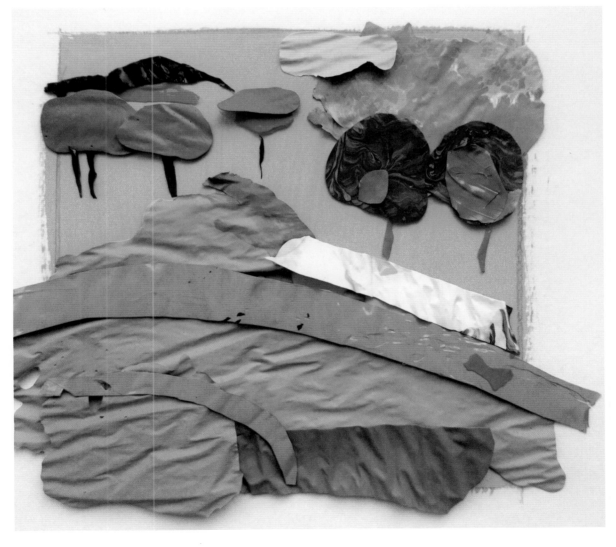

STACK OF CUPS WITH GRAPHITE

This tutorial shows you how other mediums can be used to supplement your acrylics. Graphite can add tone as well as linear marks, and it has an interesting shine to it when applied densely. Graphite sticks come in different grades, just as pencils do. I have used a 6B for this exercise, as it is one of the softer, darker grades that show up better when applied over a painted surface. Unlike pencils, which have wood around the lead, graphite sticks have no support, so your hands can get messy. Because of this, try to avoid touching your painting.

Choose a simple still life arrangement for this exercise. You can paint your subject any colour; this is simply about observing edges and tones.

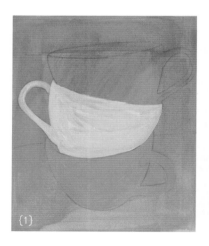

{1}

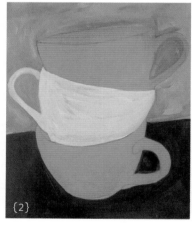

{2}

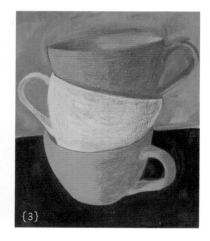

{3}

You will need: **Acrylic paper, canvas or board, a graphite stick, a chalk pastel, a baker's brush, a flathead brush and a pointed brush.**

{1} **Sketch your still life arrangement and paint it in a ground colour of a slightly thicker consistency than a wash. Vary the tones in your composition by adding white to the ground colour.** {2} **Paint the background in two tones, both darker than the main subject. I used purple and made a light lilac. Choose the various brushes according to the size of the area you're painting.** {3} **Notice where there are dark edges, perhaps where the cups meet, and use the graphite stick to add these. Now take note of the shadows and tones. Use graphite to describe these tones, making it darker or lighter by applying more or less pressure. Describe light tone very gently and leave the lighter areas untouched.** {4} **Finish by adding the highlights using chalk pastel.**

* **TIP: The graphite and chalk pencil can be fixed using a fixative such as hairspray.**

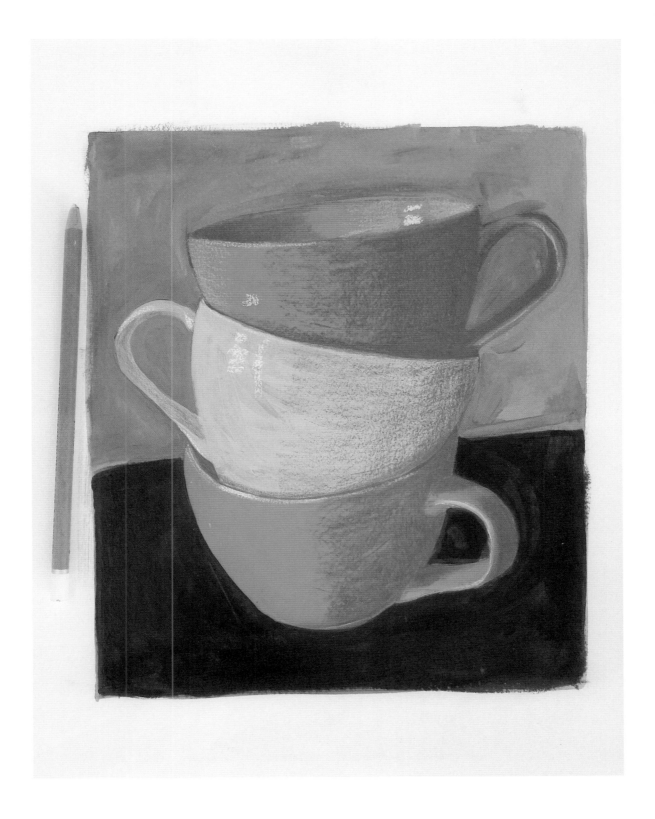

RIVER WALK WITH CHALK PASTELS

Chalk pastels are wonderful for adding detail, colour and a variety of marks to an acrylic painting. I used acrylics to paint the basic areas of a composition, and then I used the pastels to add detail, highlights and the darkest areas. In some places, I used similar colours to the background to exploit the mark-making abilities of the pastel – it can leave rough or smooth marks. For the river, I wanted contrast, so I made the acrylic background darker, allowing the pastels to stand out.

Before you begin on the real thing, first explore all the different marks you can make with pastels on a blank piece of paper.

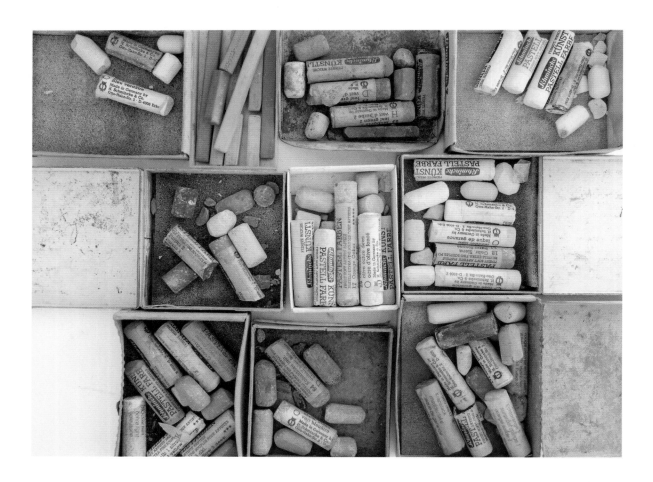

You will need: **Chalk pastels, acrylic paper, a pencil, a baker's brush, a flathead brush and filbert brush.**

{1} Using a flathead brush, paint a ground colour and draw the basic shapes of the image you are going to paint. Using your baker's brush and filbert brush, depending on the size of the area, start painting the colours of those shapes – these could be either synthetic or local colours (see page 22) or a mixture, depending on the effect you want. {2} Start painting the colours of all the areas in your painting, using either a thick or wash-like consistency. Do not add any detail. Some areas can be painted as solid block colour, and others using a little more mark-making. This gives you different textures to work with when it comes to adding the pastel marks. {3} Mix a dark tone and paint in any dark areas, again very loosely. I have added areas of dark foliage, trees and branches. {4} Start to add the chalk pastels, making simple suggestions of shapes and colours. Use them sparingly so as not to cover all the paint, but to complement it. {5} Use the chalk pastels to add in highlights and any features. I added a fence (see previous page).

* **TIP: To make the chalk pastel stand out, use dark colours for your background.**

{1}

{2}

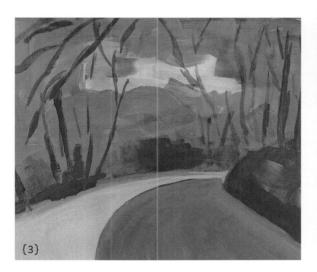

{3}

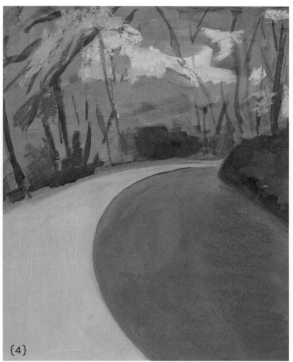

{4}

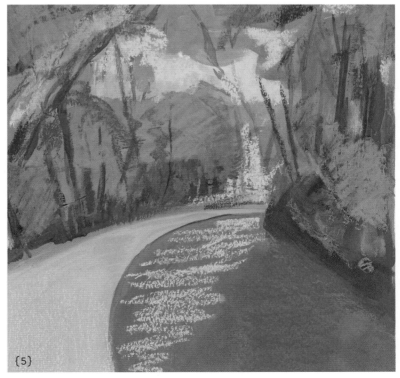

{5}

DRAWING ROOM WITH PAINT PENS

Acrylic paint pens are permanent markers that use acrylic paint instead of semi-permanent liquid chalk or ink. They come in a range of colours and can be used easily over acrylic paint, although you do have to keep shaking the pens in order to keep the paint mixture from separating.

These pens are often used to write labels, draw on glass or make images on fabric, but they can also be incorporated into a painting. They are more of a drawing tool, allowing you to use acrylics with precision, and encouraging detail. I utilized this quality and made my image quite graphic and illustrative.

For this exercise, we will be painting an interior scene. We will be painting in all the basic shapes and colours, using the paint pens to add linear detail such as wallpaper patterns.

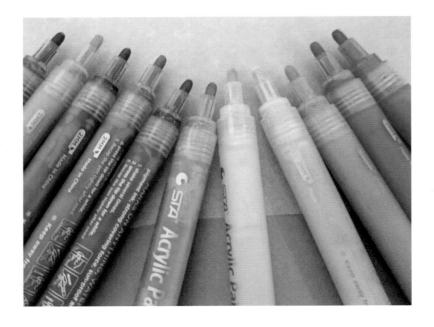

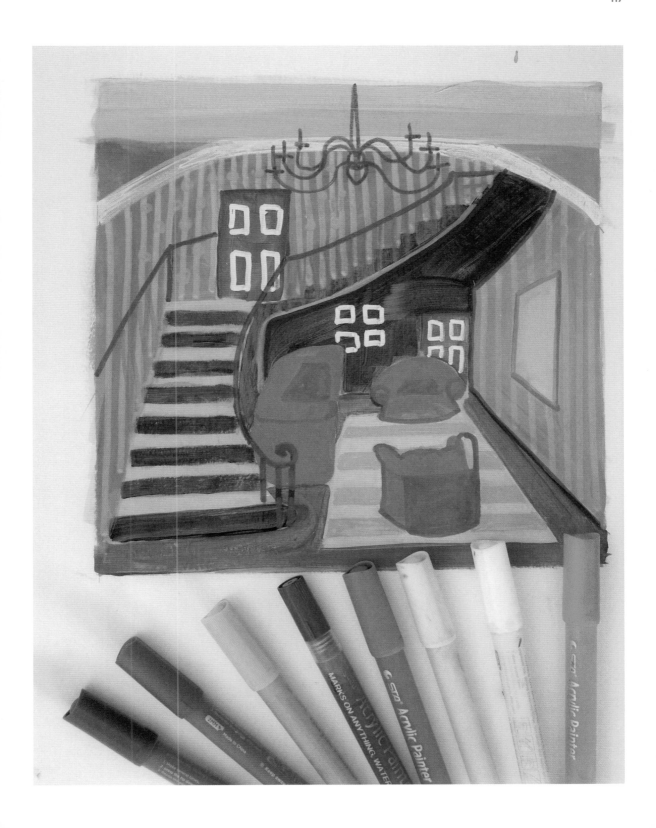

{1}

{2}

{3}

✳ **TIP:** As I used quite a strong ground,
I painted over this with a buff
titanium colour – this would still
allow the orange to show through,
but it would allow the transparent
colours placed on top to remain vivid
and not be dulled down by the
ground showing through.

You will need: Acrylic paper, canvas or board, a pencil, a flathead brush, a baker's brush, a filbert brush and a selection of acrylic paint pens.

{1} Draw an interior and then paint a ground colour using the flathead brush. When this is dry, start painting the lightest and darkest areas of the painting. Don't go into great detail; you are just painting the basic shapes. {2} Mix just two or three colours, keeping your palette simple but bright. I used turquoise, red and purple, and added these colours to white to make lighter shades. Paint the rest of the interior without detail. {3} Use the paint pens to start marking in linear details. I added a balustrade, wallpaper and frames, as well as pattern to the carpet. {4} Continue step 3 until you feel you have added enough detail. The important thing here is not to overdo it.

{4}

SCALE

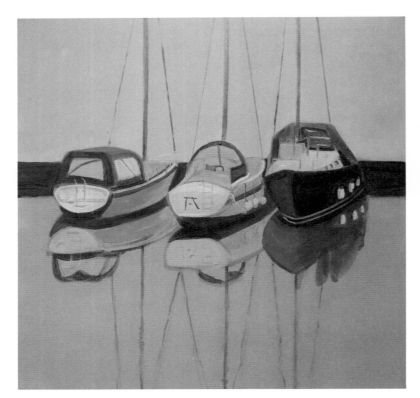

{1}

BRUSH SIZES & FORMAT – THE MARINA

✳ **TIP: The reflections will not be a direct mirror image; look for the differences and unusual shapes that will give them the feel of being reflections.**

For this image, I visited a marina to make sketches and take photographs, which I would later use as the basis for my painting. All the boats were maintained within a very square harbour wall, so I chose a square format canvas to reflect this. There were many boats, but I created a composition with just three. This exercise requires you to think about your composition and the format you are painting in, as well as your brush sizes. Make sure you have a wide selection of brushes – there are many shapes within this painting that require different brushes; for example, the masts could be painted with a very small pointed brush, while the angular brush can get into any tricky corners. Use the filbert brushes for the main body of the boats, as these are good for coverage, and the brush marks blend well.

If you are lucky enough to live by a marina, go there and make some sketches. Look at the masts and their reflections as well as the reflections of the boats. Take note of the difference in tonal value between the sea and the sky. Of course, your subject does not have to be a marina; look for a subject that will require the use of many kinds of brushes, and which seems to suggest a particular format, and use the steps opposite to guide your own decisions.

{2}

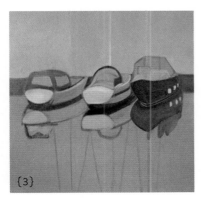

{3}

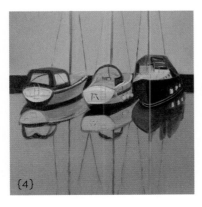

{4}

You will need: **Canvas or acrylic paper, a pencil, a baker's brush, an angular brush, two filbert brushes (medium and very small) a pointed brush, and a spotter brush.**

{1} Make up two ground colours that complement each other. I used pink made from cadmium red and white, and turquoise made from phthalo blue, lemon yellow and white. Using a filbert brush, paint the first ground colour. I made this a medium consistency – not too watery – then, when dry, paint over it with the second ground colour in the same way. The first colour will subtly show through. When dry, draw the boats; when you have decided on a definite composition, paint the basic lines using the small filbert brush – I did this using the second ground colour. {2} Lighten the second ground colour with some white and, with a baker's brush, use this to cover the sky area. Select a colour to be your darkest tone – I used phthalo blue – and paint the darkest areas using the filbert brushes and the angular brush as required. Make a watery white and paint in the top masts with the small filbert, using the side of the paintbrush to make a clear straight line. {3} Using the first ground colour (for me, the pink), paint the lighter-toned areas. Use the filbert brushes and the angular brush for the top half of the painting, and just the filberts for the reflections. The round edge of the filbert brush ensures that there are no hard edges in the reflections. Add a little of the darkest tone to the first ground colour to create a slightly darker shade, then add more tones. I added phthalo blue to pink and made lilac. Then add white to this to paint in the lightest areas with the small filbert brush. {4} Add more detail and definition by going over the darkest areas with the darkest tone made to a thicker consistency (i.e., with less water added). Use the spotter brush and the pointed brush to add the fine details of the boat, so you are really getting close to the painting and putting in the details of any ladders, handrails and so on. Water down the darkest tone and paint the masts: use a tiny filbert brush or pointed brush and the edge of another brush as a ruler for the top masts, but paint the mast reflections loosely in freehand.

GESTURAL PAINTING – ABSTRACT

This painting is 100 x 150cm (39 x 59in) – quite large. A bigger canvas opens up the realms of gestural mark-making, allowing you to work the paintbrush using whole arm movements, not just movements from your wrist and hand. The scale of the canvas requires that you stand while painting, variously stepping away from it and coming closer, bringing movement into the mark-making. I did not work from any image or subject in front of me; rather, I instinctively made marks and then responded to these marks with more. If you prefer to work figuratively, that's fine too.

When I'm working at this size, I like to hang the canvas on my studio wall. I also mix up larger quantities of paint that I keep in a stay-wet palette (see page 36).

{1}

{2}

✳ **TIP: You may find it helpful to play music making a gestural painting to encourage you to move and make marks in response to the rhythm. Remember, this is an abstract painting, you are responding to brush marks and colours you have just made.**

You will need: A large canvas (I used a shop-bought stretched canvas, so it has already been primed), a graphite stick and a selection of large brushes (I used baker's brushes and a filbert about half the width of the smallest baker's brush). This will allow for a variety of mark-making.

{1} If stretching your own canvas, prime it first before applying paint (see page 42). Mix a ground colour for the entire canvas. I used cadmium yellow with a very small amount of cadmium red to make a deep cadmium yellow. If using a heavy-bodied acrylic, a soft gel medium can be added to help spread the paint more and to bulk it out. Cover the canvas in this ground colour using a baker's brush. Mix the ground colour with a darker colour, for example some ultramarine blue with some of the yellow added to make a watery dark green. Use this to start adding shapes in sweeping marks across the entire canvas. Then add some white to this mixture and mark out some lighter areas. I used the filbert and the baker's brushes to paint in the marks. {2} Now mix the darker paint colour with just a little water so it has a fairly thick consistency. Go over some of the previous marks and block in areas; I used ultramarine blue. Mix some white with this paint and make some bolder, lighter marks. I added some white to the watery green and used this to paint in more tones. Add to the ground colour by making a slightly darker shade of it, and paint this over some parts of the ground colour. {3} Paint some of the darker shade of ground colour over some of the bolder marks. When I did this, I created some new greens. Now use a less diluted mix of the darker colour (ultramarine blue) and go over some of the previous marks, also creating new ones in response. Use the graphite stick to draw into the painting, mimicking some of the lines already painted. Add some highlights.

BOLD PAINTING – BUILDINGS

I decided to use a square canvas for this, as the image is quite abstract and the regular square shape acted as a good frame for the angular buildings. This juxtaposition adds to the painting's eye-catching quality.

I drew an image that used large shapes; each one is unique so that no two shapes were the same. Using diagonals helps move a viewer's eye around the painting, and I left a thin line of the vivid ground colour around each shape, which acts as a unifying line that the eye can follow.

Just as you make your piece more interesting by making each shape different, also spread the colours out evenly so that you don't have too much of one colour in one place. I used a very bright ground colour, so I didn't overdo the brightness of the foreground colours – the ground shows through and adds a glow, so I wanted to maintain contrast. The ground colour will also show through the lighter, more transparent colours making it more painterly and more interesting.

Bold shapes and bright colours work well on a large canvas, as the shapes break up the area and keep the eye interested.

{1}

{2}

* **TIP: Use a lighter colour in the foreground and place a dark colour at the very back, this will help achieve a sense of perspective.**

You will need: **Canvas or acrylic paper, a baker's brush, a medium and small filbert brush, an angular brush and a spotter brush.**

{1} Choose two vivid colours that are next to each other on the colour wheel: I chose orange and magenta. With a baker's brush, mix the first colour with just a little water so it is a thicker consistency than a wash; paint it on and allow to dry. Then paint on the second colour, using the same consistency. Now use the second colour with just a little water to paint the building outlines with a small filbert brush. {2} Choose another vivid colour and paint in a few of the shapes using a medium filbert or angular brush, depending on the shape you are painting. I used phthalo blue lightened with titanium white, which added to the blue's opacity. Try to avoid painting two shapes that are next to each other in the same colour, and leave some of the outlines showing. {3} Choose and mix another four to five colours, ranging from light to dark. Repeat step 2 in these colours. I used an orange, violet, purple and a buff titanium green. I used some sgraffito (see page 58) on the green lawn shape to reveal more of the ground colour. {4} To add more dimension, add shadows in a darker shade of the main colour.

{3}

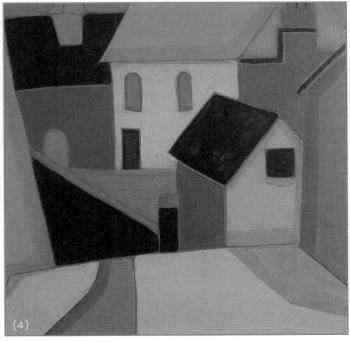

{4}

* **TIP: To mix a buff titanium green I used phthalo blue and lemon yellow with a little buff titanium to get a creamy light green that sits well with oranges and blues.**

INDEX

ACKNOWLEDGEMENTS

I would like to thank Kim, Poppy, Jasmine, Tristan and Chris. My fellow artists on the north corridor at Phoenix, and my Dad, Dennis, who has been a constant supporter of my art.

PICTURE CREDITS

8–9: weareaway / Pixabay; 10c: Tim Gainey / Alamy Stock Photo; 10r: David Kilpatrick / Alamy Stock Photo 11: Convery flowers / Alamy Stock Photo; 14–15: nikamata / iStock; 20: ChrisAt / iStock; 24–25: Yuliya Adilova / Dreamstime.com; 28: JudiParkinson / iStock; 38tl: Chernetskaya / Dreamstime.com; 38bl: Asia Images / iStock; 40–41: Savs / Unsplash; 46–47: Steve Johnson / Pexels